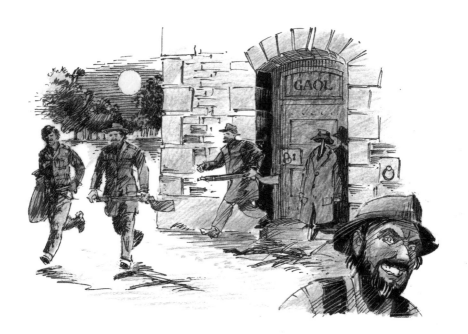

First published in 2009 by PAWS Publishing

Copyright © PAWS Publishing 2009

PAWS Publishing
waynegsmith@internode.on.net

Other PAWS Publications:
Ripper Tassie Place Names Volume One Published 2007, 2008 and 2009
More Ripper Tassie Place Names Volume Two Published 2008

ISBN 978-0-9804419-3-2

Printed by Foot & Playsted Fine Printers, Launceston, info@footandplaysted.com.au
Printed on Spicers Paper 135gsm Grange Laser/Offset and the cover is on Spicers Paper 300gsm Impress Gloss

Design by Miudesign, catspop@gmail.com

Ripper Tassie Tales

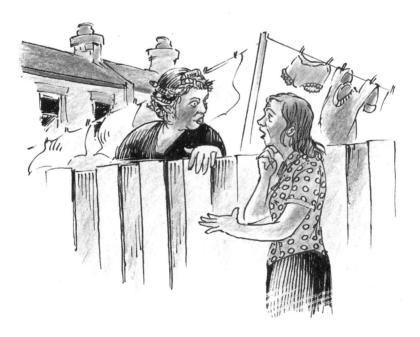

"IF YOU TELL A LIE BIG
ENOUGH AND KEEP
REPEATING IT,
PEOPLE WILL
EVENTUALLY COME TO
BELIEVE IT."

JOSEPH GOEBBELS
(SPEAKING ON GERMAN WW2 PROPAGANDA).

Contents

Proud to be Tasmanian

This book is printed in Tasmania using local materials wherever possible. The composition of the book (text, design, cartoons, photos, writing etc) is also by Tasmanians. Consequently, if you purchase this book you will be supporting Tasmanians and keeping your money here rather than assisting the economies of other states or foreign countries.

Acknowledgements

I am heavily indebted to the talented Colin Abel for his brilliant cartoons and to Miu Heath for her superb graphic design. I also appreciate the help of my son Dean for his assistance and my friend Robin Barker who has lent me books from his wonderful collection of Tasmaniana from which many of the Tassie tales in this book have been derived. I also acknowledge Robin and my friend John Houghton for kindly giving up their valuable time to edit the book. I am grateful to the many people who have allowed me to publish some of the hilarious stories that they have made available to me. I am pleased to acknowledge numerous authors, many of them now deceased, who have taken the time and risked their money in publishing stories on folklore, thus preserving an important part of our history. Finally, I appreciate the freedom my loving wife Pauline has given to me whilst I have been selfishly compiling an impressive data base of ripper Tassie tales.

Images

All photographs included are from the private collection of the author unless marked otherwise.

All illustrations are by Colin Abel unless marked otherwise.

Conversion Tables

1 guinea	= 21 shillings or A$2.10
1 pound	= 2 dollars
1 shilling	= 10 cents
1 penny	= 1 cent
1 fathom	= 1.8 m
1 acre	= 0.4 hectares
1 mile	= 1.6 km
1 yard	= 0.9 metres
1 foot	= 30 centimetres
12 inches	= 1 foot

Abbreviations

'	= Feet
"	= Inches
£	= Pound (money value)
ADB	= Australian Dictionary of Biography
c.	= Circa (i.e. about)
Capt.	= Captain
DVC	= Derwent Valley Council
E	= East
HEC	= Hydro Electric Commission
HMS	= His/Her Majesty's Ship
HTC	= Hobart Town Courier
HTG	= Hobart Town Gazette
kms	= Kilometres
LCC	= Launceston City Council
Lt.	= Lieutenant
m	= Metre
N	= North
RACT	= Royal Automobile Club of Tasmania
S	= South
SS	= Steam ship
THRA	= Tasmanian Historical Research Association
UFO	= Unidentified Flying Object
W	= West
WW2	= World War 2

Chapter 1

Introduction

This book sets out to highlight, record and preserve some of Tasmania's unique and often astonishing folklore. It chronicles some thrilling events, fascinating sagas, amazing epics and dangerous adventures and also features many wonderful anecdotes of our colourful past. To provide a balance between truth and fiction, the book is laced with a few outrageously tall tales that readers may believe at their own peril.

The text includes many ludicrous, scandalous and comical incidents, interwoven with gruesome and macabre stories from our colourful past. Many of the tantalising tales are 'recycled' from old or out of print books to ensure that these early wonderful memories are not lost to the present generation. A few of the stories may be familiar to the older generation, but as they are ripping yarns, they are worth re-reading. Most of the information recorded is not generally known and many of the anecdotes have never been published before.

The quotation on page iv was deliberately chosen to emphasise that much of the history, folklore and stories that we have grown up with are rubbish. Henry Ford is famous for his quotation *'History is bunk'* and this applies equally to Tasmanian history. Many incorrect facts have been published over and over again and gain credence by repetition. Newcomers to Tasmania are warned not to believe everything that they are told about our magical past or to believe everything that they read on brass plaques or in books about Tasmanian history. The following examples of questionable statements are mentioned in the book:

- Truganini (properly Trugernanner) was NOT the last Tasmanian Aborigine – see p 12.
- Martha Hayes was NOT the first white woman to land in Tasmania – see pp 12, 78.
- The Pieman River was NOT named after cannibal convict Alexander Pearce – see The real Tommy 'the Pieman' p 44

In conclusion, this book can be summarised as 'historical or hysterical stories', or 'history without the boring bits'.

Tasmania, the best ripper tale of them all

I have heard people say that Tasmania has a bland and uninteresting history compared to Europe. Just because Australia is one of the newest countries in the world (from a white person's perspective), does not mean that we have no history. Australians, and Tasmanians in particular, seem to be ashamed of our early history and we don't talk much about our unhappy convict heritage or the injustices towards the original inhabitants.

On the other hand, North Americans know how to celebrate their adventurous and bloody past, and they circulate romantic stories and films about the opening up of the 'wild west'. The Tasmanian equivalent of America's cowboys and Indians were stockmen versus Aborigines in pioneer fringe settlements and our gunslingers were escaped convicts or bushrangers. These gunmen continually created terror and havoc until they were captured and executed, usually within two years of their escape into the bush.

The Tasmanian goodies and baddies were consequently soldiers/policemen versus bushrangers.

If we are searching for exciting adventure stories, Tasmania has an immense archive of stranger-than-fiction epics and sagas of riveting conflicts and heart-breaking shipwrecks. Unfortunately not much Aboriginal folklore has been recorded despite continuous occupation by indigenous people for many thousands of years. However, the diaries of settlers, government records and early newspapers have documented some fascinating events since the arrival of the British in 1803.

Much of our early folklore was dominated by tales of bushrangers who committed many atrocities amongst both the black and white communities and habitually attacked the richer settlers and made off with food, refreshments, money, jewellery, clothing, livestock, and guns and ammunition. Like the whalers and sealers had done before them, bushrangers also attacked Aboriginal camps and kidnapped native girls and sometimes killed the men. These bushrangers and the soldiers who pursued them, were among the first white land explorers and this helped to open up the country to a continual and steady influx of British settlers.

As more and more settlers arrived, they gradually usurped the traditional hunting grounds of the original inhabitants who naturally retaliated by attacking settlers and robbing their huts of food.

In the course of the next one hundred and fifty years there were many new waves of 'invasions' of Tasmania to create the multicultural society we enjoy today. The Irish potato famine of the 1850s saw a huge influx of new Irish settlers arriving at our shores, followed by many Germans and Danes who arrived here between 1850 and 1880 to escape religious persecution and horrific living conditions in Europe. Chinese miners flocked here during the mining boom of the late 1800s. After WW2 many British migrants headed to our shores to begin a new life to escape the devastation of England and Europe. The Hydro Electric schemes of the early 1950s induced a wave of 'new Australians' from Europe (in particular England, Poland and the Baltic regions) to make a fresh start in Tasmania with a job guaranteed for two years. In more recent times, a gradual influx of Asian and African migrants has added to our present-day multiculturalism.

Tasmania is richer for this, and there are many funny stories arising out of misunderstandings between these various migrant groups. Tasmanians have always teased new arrivals and told them outrageous stories about what they can expect to find here. This started with our convict forebears attempting to unsettle 'new chums' or 'green' settlers with some light-hearted leg-pulling about wild animals, ghosts, monsters, bunyips and atrocities on pioneers by Aborigines and bushrangers. Naturally this made pioneers have second thoughts about their aspirations to settle in a wild and dangerous environment. This was the beginning of today's folklore and many of these tall tales have survived to this day.

Chapter 2 Tasmania – the land of giants

Tasmania was named after Abel Janzoon Tasman (c1603–1659), the first recorded European navigator to sight Tasmania. Ironically, Tasman himself did not step onto the land that was subsequently named after him. The intrepid mariners anchored in North Bay, Tasman Peninsula on 1 December 1642 and went ashore the next day to explore the land that they had 'discovered'. Contrary to their instructions, the sailors made no effort to contact the local natives as they believed that the land was inhabited by fearsome giants. Early maps and charts of the world showed images of giants and sea monsters in the waters of the South Seas, so it comes as no surprise that Tasman and his crew believed that the land they had just found may be inhabited by giants. The journals of Tasman dated 2 December 1642 give a fascinating insight as to the thoughts of the visiting sailors.

'Early in the morning we sent our Pilot-Major Francoys Jacobsz Vissher in command of our pinnace, manned with four musketeers and six rowers, all of them furnished with pikes and side-arms, together with the cock boat of the *Zeehaen* with one of her second mates and six musketeers in it to a bay [Blackman Bay] situated northwest of us at upwards of a mile distance, in order to ascertain what facilities (as regards fresh water, refreshments, timber, and the like. …) That they heard certain human sounds, and also sounds nearly resembling the music of a trump or a small gong not far from them, though they had seen no-one. That they had seen two trees about 2 or 2 ½ fathom in thickness, measuring from 60 to 65 feet from the ground to the lowermost branches, which trees bore notches, made with flint implements, the bark having been removed for the purpose; these notches, forming a kind of steps to enable persons to get up the tree and rob the birds nests in their tops, were fully 5 feet apart, so that our men concluded that the natives here must be of very tall stature, or must be in possession of some artifice for getting up the said trees; in one of the said trees these notched steps were so fresh and new that they seemed to have been cut less than four days ago. That on the ground they had observed certain footprints of animals, not unlike those of tiger's claws [thylacines?]; … in the wood they had also seen clouds of smoke ascending. So that there can be no doubt that there must be men here of extraordinary stature.'[1]

1 *Discovery of Tasmania 1642* Government Printer pp 39-40

Chapter 3

Tasmaniacs

Two-headed Tasmanians - double the intelligence

For many years Tasmanians have been the butt of good-natured jokes from residents of the Big Island about being the bearers of two heads, with one being amputated (in my case they removed the wrong head). Consequently, Tasmanians receive requests to 'show us your scar' (although show-biz personalities are sometimes crudely asked to show other anatomical parts). The unspoken implication from the two-headed jibe is that Tasmanians are in-bred and a 'bit thick'. However, the truth is quite the reverse. It is an irrefutable fact that Tasmania's continually low population figure, is the result of a constant 'brain drain' to mainland Australia. Because of the small number of large industries in Tasmania, and the consequent limited job opportunities, young Tasmanians with 'get up and go', simply 'get up and go' to the mainland to get jobs (thus doubling the intelligence of the destination town or city). Tasmanians are highly valued in Australian business houses as they are usually multi-skilled. In Tasmania's smaller environment, workers are forced to learn many skills which contrast strongly with many mainland employees who become specialists in large enterprises and consequently only learn one skill. Therefore, it is an enormous advantage to have a number of multi-skilled workers who can fill in for specialists when they are ill or on leave. Perhaps two heads are better than one after all (as Tasmanians can do two jobs at the same time). Two heads are also useful when you talk to yourself or if you need to bang a couple of heads together.

Are all Tasmanians related?

The humorous ribbing from mainlanders that all Tasmanians are related probably has its genesis from accusations of in-breeding in some isolated communities. This eventually led to the generalisation that all Tasmanians are related. In-breeding has undoubtedly occurred here, as it has in relatively inaccessible or isolated communities in many parts of Australia. It is also true that in-breeding may have produced some simple-minded children. It is hard to know why Tasmania was singled out to be the prototype of inbred families in Australia, but stories abound of rampant incest occurring in some Tasmanian communities and bogans chaining 'dangerous' children to posts or trees as if they were ferocious dogs. Although I am loath to admit it, there appears to be a basis of truth to these stories.

One infamous family in the backblocks (that shall remain nameless), reputedly tied up some of their kids alongside the dogs when they went to town. According to legend, the entire family slept in one room of the house. One day a health inspector visited the family and noted that the boys and girls all slept together. The inspector insisted that the room would have to be partitioned. When the inspector returned to see if segregation had occurred, he found that the big room was divided by a post and rail fence. It is hard to tell if there is any credence to this shocking (but amusing) story, but it has now become accepted folklore. It is firmly hoped that it was just an isolated incident and there were not too many families who behaved in this idiotic fashion. In any event, it begs the question: if all Tasmanians really are related - does this make me my own grandpa?

The Tasmanian tiger

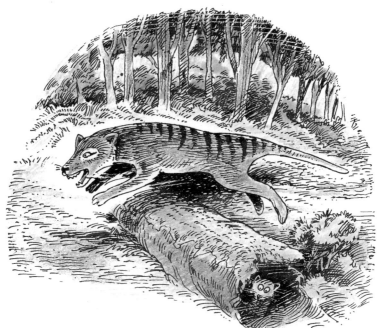

Are there any thylacines out there?

That is the $64 question. The Tasmanian tiger (or thylacine) is Tasmania's state icon but we cannot state categorically that it still exists. It remains Tasmania's biggest unsolved mystery, despite several high profile and expensive expeditions being mounted to solve the problem. By the 1920s bounty hunters and farmers had almost hunted the marsupial tiger to extinction in the (probably erroneous) belief that it was a habitual sheep killer. We know that there are foxes in Tasmania but by July 2009 we have not yet found a live one. This being the case, how can we be so certain that thylacines are extinct?

A shop keeper in a remote north-eastern Tasmanian town around fifteen years ago told me that the thylacine still existed in the area and that several locals had frequently sighted the animal. The shopkeeper claimed that the wildlife authorities knew where the tiger lair was located but were keeping this information quiet to avoid efforts to shoot or trap a tiger to gain notoriety. My brother Dale's father-in-law (the late Graeme Rabe) and his son Michael Rabe saw a tiger crossing the road near Mengha, Stanley in the 1960s. Dale also told me that commercial traveller David Blackburn claimed that he had sighted a tiger in his car headlights near Scottsdale in 1990. In 2007 three tourists during a helicopter flight over the King River near Strahan swear that they spotted three Tasmanian tigers in a clearing. They were able to see the distinctive stripes quite plainly from the air. Three people could hardly have been having hallucinations simultaneously, so I believe that the sightings were credible and that the elusive thylacine is not yet extinct.

The tiger donger

An amusing yarn is told by the Smith and Hay families who lived at Southport for several generations. In the 1920s William Smith, Frank Chesterman and Nat and Robert Hay were on a prospecting trip in the South-West. One night a tiger appeared at their camp site and one of the party shouted, *'Give him the meat, give him the meat,'* presumably referring to some pre-poisoned bait for tigers. However, Nat Hay promptly gave the animal a nasty blow on the head. To his surprise he soon found out that he had donged his friend Frank Chesterman. Frank had earlier discovered the skin of a large, recently deceased Tasmanian tiger and he decided to drape it over his back to play a prank on his friends in the half-light of their camp fire. However, he nearly became extinct himself and he was lucky to survive to tell his grandchildren of his misguided hoax.[2]

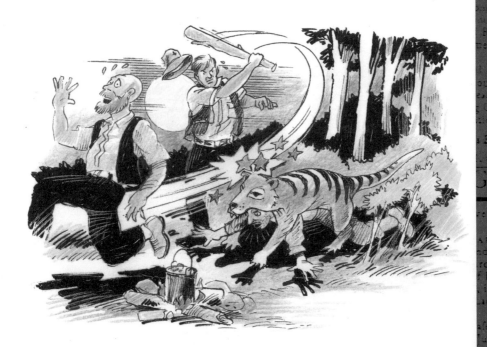

2 Further reading: *Battlers from the Bush* (Bruce Poulson) Southport Community Centre 1999 p 10

The wombat - the 8th wonder of the world

The Wombat - *Vombatus ursinus*
Is out of this world, p'rhaps from Venus.
Its lifestyle is wicked, too good to believe,
It eats roots - shoots - and then bloomin' leaves.
But when that great diet is soon well-digested,
The bowel must void all those goodies ingested.

It's hard to believe, it's completely absurd,
But a wombat produces a cubic-shaped turd.
This doesn't make sense and I wordlessly wonder,
If God has not made a phenomenal blunder.
How can a scat like spectral cube,
Vacate from a roundish rectal tube?

Does a wombat scream with anguished emotions,
While passing impossible, cubic-edged motions?
Does it close its eyes and grimace with pain,
When it voids its bowels upon the plain?
We know a square peg won't fit a round cavity,
So to pass a square turd, is the height of depravity.

But somehow they do it, and rarely complain,
And once they have scatted, they do it again.
Our knowledge can somehow never transcend,
This mystery surrounding a wombat's rear end.
Will the answer forever be never unfurled?
It's the 8th bloody wonder - of our brave new world.

- Wayne Smith

Chapter 4 Believe it or not!

One of the most sensational and unbelievable stories in Tasmania's history centres around the life of Samuel Emanuel Jervis (aka 'Sammy' Cox) (c1773-1891). Sammy claimed that he was the son of Roman Catholic squire Jervis of Shenstone Park, Lichfield, England. Sammy was orphaned at ten years of age when his father was killed when he fell from a horse whilst fox hunting. Sammy became a ward of his uncle John Jervis who later took him in the whaling ship *Regent Fox* on a voyage to the South Seas. Sammy was appalled when the ship's boatswain told him that his uncle intended to abandon him on an uninhabited island in order to claim his inheritance. Sammy resolved that he would jump ship at the next landfall. Consequently, when the ship sought water at Tamar Heads in 1789, Sammy scarpered into the bush and the ship was forced to leave without him. Sammy fortunately fell in with some friendly Aborigines and he lived with them for twenty three years. In 1812 Sammy met some pioneer settlers near Deloraine and went to live with Elias Cox who had a farm in the Pateena district east of Longford.[3]

3 'Elias' Cox appears to be John Cox (1764-1848) whose family arrived in Van Diemen's Land in April 1813. John Cox had a farm named *Jessiefield* near the Pateena Bridge, Longford. By sheer coincidence[?], one of his children was named Samuel Cox (1800-53) (source: AOT Correspondence Samuel Cox)

Sammy worked as a gardener for many years for various settlers at Pateena, Carrick and Longford. He told his incredible story to Thomas Monds, a flour miller at Carrick, who decided to document it for posterity.

In 1885 Monds visited England to verify Sammy's story. As Sammy became older and weaker, Monds persuaded Sammy to enter the Launceston Benevolent Society's Invalid Depot. Sammy died there on 5 June, 1891 at the age of 117 years (if he is to be believed). In 1900 the Invalid Depot, received a letter from EWT Jervis of Frankston, Victoria containing information which supported Sammy's claims of his origins. The writer claimed to be a grand nephew of Sammy and he sought a photo of Sammy and any of his belongings to forward as mementos to his Jervis relatives in England who are still Lords of the Manor at Lichfield.[4] Sammy's uncle Capt. John Jervis could well be the Sir John Jervis (1735 – 1823) who became Admiral of the Fleet and was created Earl St Vincent when he celebrated a famous victory under Lord Nelson at the Battle of Cape St Vincent, Portugal in 1797. Jervis Bay NSW is named after him.

If this incredible story is true (and it seems to be), it will be necessary to rewrite our early history. For example:

1. Bass Strait now appears to have been 'discovered' by Capt. John Jervis in 1789, nine years before Bass sailed through it.
2. Capt. John Jervis also 'discovered' the River Tamar before Flinders (1798).
3. This story upsets all the previous claims as to which white person was the first permanent settler to live in Tasmania.
4. Sammy's life with the Aborigines predates by thirteen years the much-publicised similar experiences of William Buckley, the 'wild man of Australia'.
5. If he got his facts right, Sammy Cox lived until he was 117 years old and was thus the oldest person ever to live and die in Tasmania (and possibly Australia).

Is this story fact or fiction? You be the judge. In any event, it is a ripper yarn by any standards.

4 Further reading: *ADB; Oxford Companion to Australian History* South Melbourne 1998 Vol 1 p 685; http://www.genuki.org.uk/big/eng/STS/Shenstone/index.html; http://www.launceston history.org.au/2005/sammy-cox.htm

Chapter 5 Exploding some myths

Do not believe all you read in history books or on brass plaques. The following popular, but inaccurate myths are those most frequently quoted, even to this day:

Truganini was NOT the last Tasmanian Aborigine
It is often reported that Bruny Island Aborigine Trugernanner [aka Truganini] (c1812-1876) was the last of her race. However, Trugernanner was outlived by Betty, Sal and Suke (d1888), three female full-blood Tasmanian Aborigines living on Kangaroo Island, South Australia. In any event, there are many descendants of Tasmanian Aborigines thriving in Tasmania today.[5]

5 Further reading: *Companion to Tasmanian History* (Alexander) Centre for Tasmanian Historical Studies Hobart 2005 p 7

Martha Hayes was NOT the first white woman to land in Van Diemen's Land
Martha Hayes was Lieutenant John Bowen's mistress in the early 1800s and she
always claimed that she was the first woman to leave his ship at Risdon. However,
Martha had been preceded eleven years earlier by a French woman by the name
Marie Louise Victoire Girardin (1754-94) who arrived with the d'Entrecasteaux
expedition in 1792/3.[6]

Mount Nelson was NOT named by Capt. William Bligh after the ship
Lady Nelson
This popular myth was initially recorded in West's *The History of Tasmania* first
published in 1852 (pp 46, 562) and is perpetuated on a plaque at the summit
of Mt. Nelson. Bligh named a hill on Bruny Island after his gardener Nelson.
Governor Macquarie's journal note of 30 November 1811 states: '... *this high hill
... I have named Mt. Nelson.*' Although Macquarie came to Van Diemen's Land in
1811 aboard the ship *Lady Nelson*, his journal note makes no mention of the ship.
Macquarie almost certainly wished to honour Admiral Horatio Nelson who died
at the Battle of the Nile in 1805.

Lady Jane Franklin was NOT the first white female to climb
Mt. Wellington
A twelve year old New Town girl named Sophie Pitt climbed the mountain in
1812 with a young companion, 25 years before the Franklins arrived. Nevertheless,
many books and web sites today still give the honour to Lady Jane.

Tunbridge was NOT named after the *Tunbridge Wells Inn*
The *Tasmanian Almanack* of 1829 records Tunbridge as a new township. This
predates *Tunbridge Wells Inn* (built 1834) and discredits the popular myth that
the town is named after the pub. A plaque at Tunbridge perpetuates this myth.

The Pieman River was NOT named after the cannibal convict Alexander
Pearce or Jimmy the Pieman (see p 44)

Mount Dromedary was NOT named after Governor Macquarie's ship
Governor Macquarie is frequently quoted as naming Mt Dromedary after HMS
Dromedary in 1811. However, the Rev. Bobbie Knopwood's diary of 12 April 1806
records the name five years before Macquarie arrived here. The peak derived its
name from its shape; i.e. similar to a dromedary a one-humped Arabian camel of
the genus *Camelus dromedarius*. However, as this mountain has two humps, its
shape more closely resembles the two-humped Bactrian camel (*Camelus bactrianus*).
I might facetiously add that the range should have been called *Mt Camel* with the
front hump named *Mt Bactri* with the rear being *Mt Anus*.

6 Further reading: *Voyage to Australia & the Pacific* (E & M Duyker) Melbourne University Press
 Carlton South, Victoria 2001 pp xxv, xxxv; *Citizen Labillardiere* (Edward Duyker)
 The Miegunyah Press Carlton South, Victoria 2003 pp 150, 198, 292

Chapter 6 — Tales from the old days

The naked vicar

The following ripper Tassie tale appears to be an embellishment of a more mundane story, but we won't let the facts interfere with a rollicking good yarn.

A kind-hearted and gentle pioneer preacher of Swansea was renowned for being under his wife's thumb. He spent a lot of time travelling around the countryside on horseback attending to his parishioners and so it was inevitable that he would have the occasional brush with outlaws lurking in these lonely parts. On one particular afternoon he was riding along a tree lined section of the road when he was accosted by two rough looking men. He was ordered to dismount from his horse. He was then robbed of everything he had with him; including his horse, his little travelling bag and every stitch of clothing he was wearing. It was almost dark when the preacher reached the nearest farm and he broke off a leafy branch to provide a modicum of modesty. He called out to a farmer who was milking a cow near the back door of the cottage and the man came over and listened to the preacher's tale of woe. The naked preacher was smuggled furtively inside the cottage and ushered to a bedroom where he hurriedly climbed into bed. The highly embarrassed preacher was offered a cup of tea and a meal by the farmer's wife. After the meal he told the spellbound couple of his brush with the bushrangers. The farmer kindly offered his only suit of clothing to the preacher and the hostess later brushed it to make it more presentable. She then hung it up outside on the clothes line to air overnight. As soon as the farmer and his wife retired, the preacher fell fast asleep. He awoke at dawn when he heard someone at the back door bellowing with anger and swearing prodigiously. This alarmed the dogs and they began to bark excitedly, adding to the uproar. Suddenly the preacher's door was flung open. The farmer's wife ruefully showed the bewildered preacher the few tattered remains of her husband's suit which a calf had pulled from the clothes line overnight and had half eaten it. The only other clothes the farmer had left were the ones he was wearing so the preacher was faced with a thorny dilemma. In the meantime, the preacher's assertive wife woke up with a headache and realised that it was Saturday and her missing husband had to deliver a sermon the next day. She rode off hurriedly in a horse and gig to look for her errant husband. She determined to box his ears and give him a piece of her mind for making her worry about him.

She soon saw a horse trotting towards her and by this time she was furious. The rider appeared to be a woman sitting astride the horse. This was something that no lady of class would ever do. Her skirts were all bunched up around her middle and her naked legs were on display. The preacher's wife was appalled and she had to curb her tongue in case she told this uncouth woman what she thought of her.

'Is that you Clara? Thank goodness!' came a familiar voice. Clara looked up to find her husband coming home wearing female clothing.

'Come home at once,' she snapped. *'Before any of the parishioners see you dressed up like a common tart.'* Later on the preacher gratefully returned the clothes to the farmer's wife all nicely washed and ironed with a note of thanks pinned to them. And that's the naked truth – or is it?[7]

The wheelbarrow race

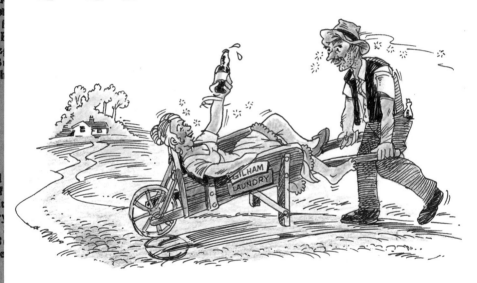

Mag Gilham and her husband were colourful characters who ran a spotless laundry in the Latrobe district. At the end of each day, they would deliver the finished clothes and linen to customers on a wheelbarrow. This happy-go-lucky couple loved a drink or two after work, and, after they finished their wheelbarrow rounds, they would usually retire to the nearest pub with money in their pockets. After spending most of the money that they had just earned, the more sober of the two would wheel the other home in the wheelbarrow. They would be invariably singing merrily as they dodged traffic on their way. It is a wonder that they weren't arrested for drink-pushing.[8]

7 Further reading: *Pioneers of the East Coast* (KR von Stieglitz) Evandale 1955 pp 73-75
8 Further reading: *A Short History of Latrobe* (KR von Stieglitz) p 27

The ingenious Treasury heist

One of the most audacious thefts in early Hobart Town occurred on 18 June 1827 when the Colonial Treasury was robbed. The robbery was meticulously planned to take place on the anniversary of the Battle of Waterloo when military personnel would be in a celebratory mood. The heist took place shortly after the sentries had changed guard at six pm. Convict blacksmith Charles James had previously been given an impression of the Treasury door key marked in soap by Matthew Pennell a convict messenger working at the Treasury. After the key had been carefully cut by Charles James and tested by Pennell, it was returned several times for minor modifications until it operated perfectly. This pair employed the same methods to hone keys to use on the door of the treasurer's office and the strong box located behind his desk. On the evening of the robbery, convict James Davis walked up to Private Thomas McGuire of the 40th regiment the sentry at the front door. He offered the guard a pint of brandy, to celebrate the famous battle. McGuire did not wish to be seen drinking whilst on duty and he was persuaded to go to the rear of the building where Private Patrick Rice was on duty. The two sentries could then enjoy a convivial drink with less chance of detection. While the front door was temporarily left unguarded, James Thomas and Charles James used the duplicate key to gain admittance. Once safely inside the building the men gained access to the Treasurer's office. The warning bell at the back of the door had been earlier rendered inoperative by Pennell. At 2 am, the robbers then had to call on the services of yet another accomplice George Ralph to help them carry the considerable booty of around £1300 in Spanish dollars, rupees and silver coin through the empty streets of Hobart Town. The robbery was discovered early the next day when a £20 cheque was found lying on the treasury floor. The sentries on duty were the first suspects and they were arrested and locked up. It soon became obvious that fake keys were used to gain access to the doors and chest and the public blacksmith who originally made the keys was also arrested. A reward of £50 was posted accompanied by a promise of a free pardon to any prisoner who was prepared to give information that would lead to an arrest. James Davis was influenced by this and gave evidence against his coconspirators. However, his evidence was not needed as the boasts of the burglars soon led to their own undoing in such a small community. A lavish supper was provided at Bernard Walford's public house to celebrate the brilliant coup. After a few convivial drinks Thomas began to vainly boast of his involvement and he repeated his claims at the *Waterloo Hotel*. Eventually, four of the conspirators were arrested following another sumptuous lunch. At the consequent court case, the solicitor general failed to show up and the judge was forced to instruct the jury to find the defendants not guilty. Thomas and James had to be re-arrested and they were sentenced to 7 years transportation along with Thomas McGuire the sentry who was bribed with brandy and Matthew Pennell the messenger who provided the inside information and disabled the alarm system.[9]

9 HRA III VI p 211-228. Further reading: *Closing Hell's Gates* (Hamish Maxwell-Stewart) Allen & Unwin, Crows Nest NSW 2008 pp 45-47

The Order of the Garter

The family of Launceston journalist Henry Button employed an Irish convict house-servant named Mary who was *'an immense woman, tall, stout, powerful, dirty'*. One day in the 1840s Henry's mother was preparing a round of beef for cooking and she began to look around for some more string to tie the meat in place. Mary helped out by promptly throwing up her dress and removing her garter. She proudly presented the filthy garter and suggested that it was *'a lovely bit of tape that would do well'*. Unfortunately, Button did not record if the generous offer was accepted, nor did he comment on whether the garter-garnish improved the flavour of the meal.[10]

Filling 'Fanny'

The hotels in old Hobart often had fantastic names like *Labour in Vain, Help me Thru the World, Hit or Miss, Surely we Have Done our Duty, Generous Whale* etc. One pub with a fancy name was the *Hole in the Wall* in Murray Street (opposite Myers). The reason for the strange name was that it was a narrow building recessed well back from the street between neighbouring buildings.[11] The licensee of this pub from 1879-89 was a colourful character named James Ogilvie, better known as 'Concertina Jimmy' as he entertained his customers by playing a concertina. One of the attractions of this pub was card playing that often continued well into the night. Jimmy kept a small pudding bowl nearby as a hint that a donation was expected when customers asked for a pack of cards. Jimmy called this bowl 'Fanny' and a threepenny bit (3 cents) was deposited in 'Fanny' by each player on the first game to help cover the costs of lighting the pub. Contributions to 'Fanny' gradually increased in size as the night wore on, because Jimmy constantly complained: *'I'm not going to sit up all night watching you play cards for nothing. Someone has to pay for the light.'* As long as the games were interesting, 'Fanny' got fed regularly. This inn ceased to trade in 1889 when 'Concertina Jimmy' folded up (that's a joke) and the building became a real estate agency. Jimmy got married and the newlyweds began to operate the *Victoria Tavern* where he later died.[12]

10 Further reading: *Flotsam & Jetsam* (Henry Button) Regal Press Launceston 1993 p 46
11 Further reading: *Pubs In Hobart from 1807* (David J Bryce) Davadia Publishing Rosny Park 1997 p 80
12 Further reading: *In Old Days and These and other stories* (The Captain) Monotone Art Printers Hobart 1930 pp 73, 74

Pudding Bag Lane

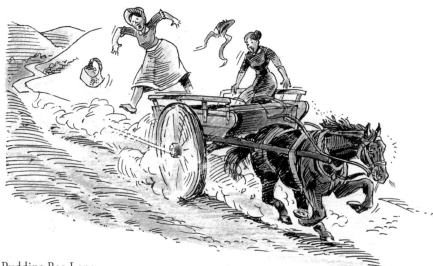

Pudding Bag Lane
(now Sale Street) in Huonville gained its evocative name when rows of pudding
bags were suspended beneath the verandas of buildings fronting this lane each
Christmas. These days we tend to buy our Christmas puddings ready made, but
in the nineteenth century it was an annual ritual for most people to make their
own and hang them up in bags to dry out. The strange lane name was a warning
to imbibers leaving the nearby *Picnic Hotel* that traversing Pudding Bag Lane was
fraught with danger. People had to run the gauntlet of the long row of pudding bags
which swung back and forth perilously at head height as they moved in the breeze.
It was hazardous enough in the daylight when the bags could be seen, but at night-
time many a reveller returned home with a sore head, not always caused by the
demon drink. Regrettably, the row of houses with verandas over the lane has long
since disappeared.

An amusing article appeared in the *Huon Times* on 19 November, 1910:

'Two young ladies, Miss Higgins of Huonville Post Office and Miss O'Brien
of Gormanston, were being driven to the Grove, by Mr. F. Page who left the
trap [a light two-wheeled cart] at the Grove Post Office for a few minutes.
During his absence the horse moved off at a trot, whereupon one of the ladies
screamed. This it appears frightened the animal and he set off in the direction
of Huonville at a full gallop. As he streaked along, both girls jumped off the
trap ... the runaway steed continued his careering along the main road. As he
approached the [Huonville] Post Office, Trooper Harmon and P Bailey made
an effort to bring him to a halt but he swerved into the thoroughfare known
as Pudding Bag Lane. Mr. Bailey followed on horse back and overtaking the
runaway pulled him up before any damage was done.'

The incredible escapades of Holy Joe

Joe's bogus cheque

Joseph 'Holy Joe' Cooper gained his divine nickname because of his pious and grandiose pretensions. Joe wasn't educated, but he pretended that he was. He also wasn't clever, but he possessed 'rat cunning' and kept breaking the law in ingenious ways so that he spent most of his life in gaol.

At one time Joe was working in a gaol gang in the grounds of Government House, when he found a blank cheque lying around. This was irresistible to Joe and he filled in the cheque and signed it with the signature of a country farmer. Joe noticed a pile of clothes in a shed belonging to Colonel St Hill, the private secretary to the Governor.

Joe promptly swapped his tatty prison clothes for the colonel's swank suit but his feet were too big for the shoes. The now sartorially splendid Holy Joe crept away from the convict gang and went shopping with the bogus cheque.

At James Robb's saddle shop he ordered some goods to be sent by train to the farmer whose name appeared on the cheque. Joe had cunningly made out the cheque for a large sum so that he would be given plenty of change. Now armed with some cold cash, Joe proceeded to J Walch and Sons to buy a piano. However, the alert shop assistant noticed that Joe's boots were scruffy and dirty and looked completely out of place with the fancy suit he was wearing. He began to ask Joe some awkward questions and Joe decided his stunt would fail and he scarpered.

He returned to his hidden clothes and hastily discarded the incriminating suit he was wearing and donned his prison garb to rejoin the gaol gang. To his dismay, the gang had retired and Joe hurried back to the prison gate where he told officials that he had fallen asleep. Although Joe's explanation was dodgy he was given the benefit of the doubt until the police came to talk to him about the fraudulent cheque. Joe was duly searched and the change from the cheque was found. Joe was tried for the offence and received a longer sentence. It would be interesting to know what Joe would have done with the piano if he had succeeded. Perhaps he could have given a rendition of *Jailhouse Blues*.

Joe the philanthropist

On a later escapade Joe visited the local Anglican minister at Sorell, masquerading as a gentleman from England who intended to settle nearby. Holy Joe was given a grand tour of the holy church and he feigned a great interest in it. Noting that the church was rather run down, Joe promised to do some renovations at his own expense once he had settled in the district. Joe explained that he had only just left the ship and was short of cash and asked the gullible minister to change a cheque for him. As Joe had generously promised to help the church, the minister didn't hesitate to oblige. Now armed with some hard cash, Joe headed straight for the local pub to celebrate his latest coup. However, Joe was recognised and the police were informed and they duly arrived to spoil Joe's party. Joe was unceremoniously returned to his cell at the Campbell Street gaol in Hobart Town only to receive yet another sentence. Eventually Joe was transferred to a lunatic asylum. Perhaps Holy Joe should have been called 'Crazy Joe'.[13]

Holy Joe's spiritual visitations

Warders of the Hobart women's prison in Campbell Street kept their provisions in a pantry that was built into a wall separating the men's and women's blocks. The pantry was replenished weekly but for some strange reason a considerable portion of the contents regularly disappeared. Female prisoners were closely watched in case one of them had found a way to access the larder.

One day Joseph 'Holy Joe' Cooper had removed some floor boards in his cell, crawled beneath the floor to the women's prison and lifted the boards there. To his amazement, Joe had discovered that he was inside a well-stocked pantry. Joe helped himself to some food and took it back to his cell to consume at his leisure.

He then returned to the pantry and replaced the dislodged floor boards. Once he had covered his tracks, Joe enjoyed a lavish banquet in the privacy of his cell. From that time on, Joe regularly helped himself to the women's provisions and he must have gained weight in the process.

Soon after Holy Joe had discovered his bonus food source, a prominent official arrived at the women's gaol who believed in spiritualism. When the officer heard the story about the mysterious thefts from the larder, he suggested that the spirits were helping themselves to satisfy their requirements. The officer began to conduct regular meetings and séances in the gaol and often strange rattling noises were heard over the usual knocks on the séance table. The mystical official claimed that this was evidence that the spirits were robbing the larder. One night in the midst of a séance, a terrible clatter and banging was heard in the vicinity of the pantry and a rush was made for the larder door. The officials then discovered that the hungry spirit was indeed a holy spirit in the form of Holy Joe.

13 Further reading: *In Old Days and These and other stories* op. cit. pp 158, 159

On this occasion, the 'spirit' had missed his footing on the shelves and Holy Joe and his stolen goodies came crashing down.

Holy Joe's world also came crashing down as he was arrested, interrogated, and placed in another cell where the flooring was securely nailed down. The floor of Joe's previous cell and the pantry floor were also promptly repaired to avoid any further 'spiritual visits' to the pantry. The magistrate was not amused by Holy Joe's ingenuity and he decided that his gaol term should be extended.[14]

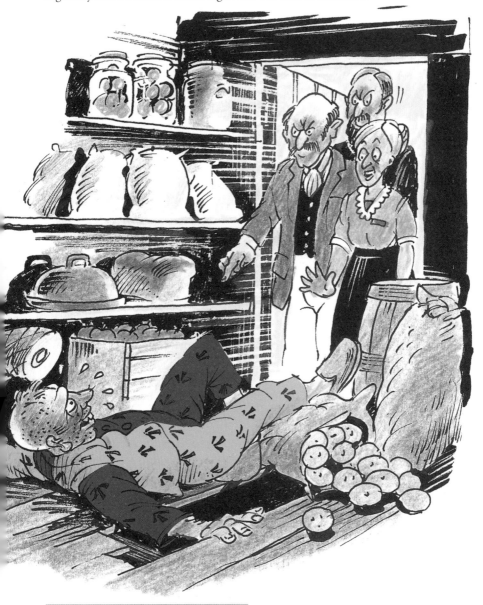

14 Further reading: *In Old Days and These and other stories* op. cit. p 159

The runaway clothes

Henry Reed, who later became a wealthy merchant, landholder and prominent citizen, arrived in Hobart Town aboard the ship *Tiger* in April 1826. Almost immediately he found a job as a clerk in Launceston. Reed decided to walk to Launceston with a fellow *Tiger* passenger named Vallance. These men told settler Alfred Thrupp of their intentions and he invited them to spend their first night on the way at his house at Brighton. The kind offer was gratefully accepted and in due course Reed and Vallance arrived at the Brighton house feeling tired and hungry. Thrupp welcomed them with a hearty meal and after chatting for a while it was decided to bed down early. The men undressed and put their clothes on a chair placed between two rough sofas. The visitors then settled down on the sofas in the sitting room. They only had a blanket each for warmth but a roaring fire kept the room warm. Reed's memoirs of the occasion written fifty years later in 1876 record the following amusing events:

'… we had not been long in bed when I noticed that the clothes seemed to move, and, looking at them closely, I saw that they were literally departing, one garment after another. I immediately jumped up and made such a noise that I brought in Mr. [Alfred T.] Thrupp, our host. When I told him how the clothes had disappeared he rushed out of the house into the hut to see if any of the men [convict servants] were absent. He found one missing. The room in which we slept was unfinished; the boards being only laid on the floor, not fixed, and this man had got into the cellar, turned them up and with a hooked stick, pulled down our clothes (which were recovered next day).'[15]

15 Further reading: *A History of Evandale* (KR von Stieglitz) Evandale 1992 pp 54-55

The very merry *Derry House*

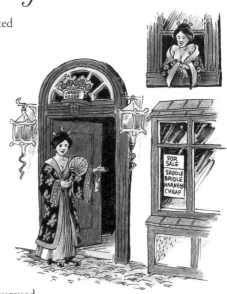

A Hobart house of ill-fame was once located near Macquarie Street at the lower end of Park Street (Brooker Avenue). One night in the 1870s, the activities of the house became more sizzling than usual when a fire enveloped it. The occupants were 'too busy' in heated carousing to be aware of the roasting fire surrounding them. George Rex and his dauntless fire brigade arrived and commenced to douse the flames. The bedlam caused by the noisy brigade members finally alerted the occupants that some calamity was occurring. The startled revellers grabbed the first item of clothing that they could find and the astonished firemen watched the passing parade as the 'ladies of the night' hot-footed it into the night, being pursued by some portly patrons. It was difficult in the smoky gloom to discern the gender of the stampeding occupants as some of the men wore lingerie and some of the women wore shirts or trousers.

The building was totally destroyed and the undaunted 'scarlet women' transferred their business to a boarding house near the site of the present Argyle Street car park. The new location was then known as the *Derry House* and it consisted of two dilapidated and disused shops. The ramshackle buildings were hastily renovated and decorated with Chinese lanterns to give them an exotic Eastern appearance and the 'uniform' for the new bawdy 'boarding house' became a kimono. A flaming red geranium was planted in an ornate china bedroom chamber-pot which was then placed on a ledge atop the doorway to symbolise the new establishment. The name of the *Derry House* was light-heartedly changed to the *Jerry House* to suit the new insignia. The occupants soon did a roaring trade from imbibers at two nearby public houses.

A sign was placed in one of the shop windows to promote the business which read: *'For sale, saddle, bridle, and harness; cheap.'* Whenever a naïve male shopper enquired about the articles for sale, he was asked to *'come inside and wait until the seller was available'*. The would-be purchaser was then plied with alcohol while he waited. Eventually, a kimono-clad 'seller' would appear and convince the now softened-up 'purchaser' that alternative 'goods' were preferable. Some straight-laced residents did not appreciate the new name of the *Derry House* and the police made the occupants remove the sign. In due course, the inmates were also persuaded to move elsewhere and the house of *Derry* or *Jerry* was no longer very merry.[16]

16 Further reading: *In Old Days and These and other stories* op. cit. pp 125, 126

How do you stop a speeding train?

Mrs. Delaney was a 'generously-proportioned' Irish lady who lived on a small farm at Rhyndaston. To supplement her meagre farm income, she sold apples from a large basket to passengers on the north-south train. She would catch the train at Rhyndaston and sell her wares by walking through the carriages all the way to Ross. Then she would do the same thing on the return journey. Mrs. Delaney had long unruly hair, a ruddy complexion, a wrinkled face and twinkling eyes. Her grubby clothing was voluminous to hide her portly frame, and was well-worn (but not worn well). She usually wore an Irish shawl thrown carelessly over her shoulders. She had cherries arrayed on her hat to hide its age and her boots were always dirty. When anyone criticized her dress sense she would bridle and announce that *'there's no need fer me to dress up just to sell apples on the train. I'm not goin' ter meet the Queen yer know'*.

One day when she was walking along the railway line to Rhyndaston she noticed that a landslide had covered the tracks. She realised at once that this was serious, as the train was due at any moment. Without hesitation, she reached under her dress and took off her red luminous, numinous, bloomers. She then raced along the line to try to stop the train before it reached the landslide. When the train came around the bend, Mrs. Delaney frantically waved her knickers to attract attention.

'Stop the train! Stop the train!' she cried out in alarm. The unnerving sight of the voluminous bloomers startled the train driver and he immediately applied the brakes, bringing the surging train to a screeching halt in the nick of time (or should that be knicker time?).

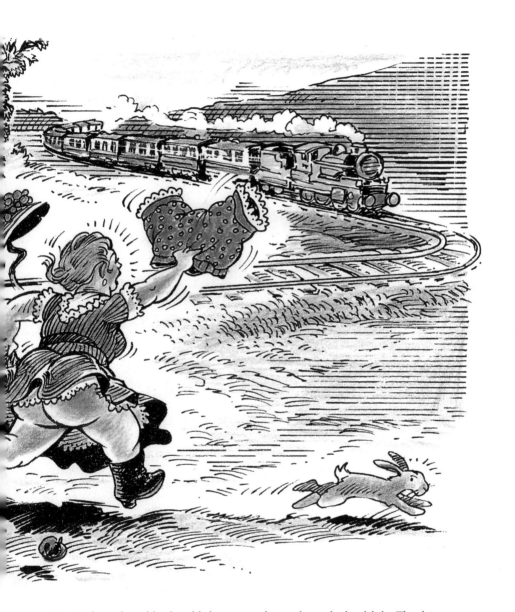

Mrs. Delaney breathlessly told the engine driver about the landslide. The driver was immensely relieved as Mrs. Delaney had averted a life-threatening catastrophe. The grateful railway company gave Mrs. Delaney a free gold pass to travel on the train for as long as she lived.[17]

17 Further reading: *My Memoirs laced with east coast tales of Van Diemen's Land* (Edward C Shaw) 2000 pp 85-86

Mad Tom's rough justice

Governor Lieutenant-Colonel Thomas Davey (1758-1823) was nicknamed 'Mad Tom' because of his eccentricity and his penchant for pulling silly faces in public. Governor Macquarie disapproved of Davey's antics and he began to undermine him by writing letters back to England reporting his:

'extraordinary degree of frivolity and low buffoonery ... [who] spent almost the entire time in drinking and in every other species of low depravity. ... such conduct rendered the Lieutenant Governor necessarily idle, indolent and totally incapable of executing the public duties of his station.'

Macquarie also accused Davey of indulging in clandestine trade and condoning the smuggling of spirits. Davey believed that he had unparalleled powers and he acted as judge and jury, often without regard for common sense or decorum.[18] Davey had a habit of *'unjustly suspending'* government officials and replacing them with his own cronies. A man who was convicted of performing an unnatural act with a dog was placed on public display in a pillory for an hour. In 1815 Davey ordered two women to wear heavy iron collars riveted around their necks as punishment. One wore the collar for a week for insolence to her mistress. The other wore the collar for three days for neglect of duty. Davey had a habit of placing women in the stocks for *'breaching the peace'* and for stealing.

Even the highly respected James Gordon fell foul of Mad Tom *'for allowing scavenging pigs to run freely in the streets'*. Gordon's animals were confiscated and probably adorned the tables at Government House.

One of Mad Tom's most infamous acts was to shoot at an inebriated man who exposed himself, turning 'his bare flesh' towards Government House. Davey was reputedly a crack shot and he called for his rifle and he aimed at the offending 'naked part'. According to the diaries of John Pascoe Fawkner, the Lieutenant-Governor 'actually struck him not mortally, but severely'. It was six months before the wounded man was able to go back to work again. He was probably awarded the DSO (I'll allow you to work out what the acronym means).[19]

18 Further reading: *ADB*
19 Further reading: *Lawless Harvests (Alex C Castles) Australian Scholarly Publishing N Melbourne 2007 pp53-5*

The Count of no account

The burgeoning town of Launceston was feverishly excited to learn on 1 January 1812 that *'a person of extreme importance'* was coming up the Tamar aboard his 120 ton brig *Active* (Capt. R Mason). The VIP claimed that he was Count Jonathon Burke McHugo, who was a first cousin to King George III. News had come down from George Town that the regal visitor expected to be welcomed with the honour due to his royal rank. Flags were hastily run up in the town and a small cannon gave a salute to welcome the exalted visitor as the ship came into view. After the ship docked, the breathless crowd on the boardwalk waited expectantly for the royal visitor to appear. Eventually a smartly-dressed and pompous gentleman came into view. He stepped grandiosely onto the gangway and walked imperiously down it with his man-servant following at a discreet distance behind.

With a magnificent gesture the newcomer announced to Major George Gordon, the Launceston Commandant, that during his sojourn in Van Diemen's Land he would assume supreme command of the settlement. Major Gordon accepted this advice without demur as he was not too bright (purportedly due to suffering severe sunstroke whilst serving in India). The Count was then regaled with the best food and wine that Launceston could provide whilst the flustered major did his best to entertain his haughty guest. During his short sojourn, the Count clapped Major Gordon in jail and gave extraordinary orders to the early settlers.

Eventually the police magistrate Capt. William Lyttleton arrived back in town from a trip to his home at nearby Hagley. He saw at a glance that Count McHugo was clearly an imposter and was *'as mad as King George'*. Lyttleton ordered the guard to release the gullible Major Gordon from prison and to return the visitor in chains to the ship *Active* which was due to return to Sydney. The 'Count' was dragged away raging and fuming and Major Gordon began to fear dreadful reprisals if Lyttleton had made a mistake. As a result of this astonishing and amusing interlude, Major Gordon was summonsed to Sydney by NSW governor Lachlan Macquarie and he was given a good dressing down for being so gullible and foolish. He was replaced as Commandant in November of that year.[20]

20 Further reading: *Hadspen to Westbury* Bulletin 2 (Royal Society) August 1973 (KR von Stieglitz article 7 November 1954), *Shipping Arrivals and Departures Tasmania Vol 1* (Ian H Nicholson) Roebuck 1985 pp 30-31

Recent anecdotes

This poem reflects a true story as recorded by an old shearer

The day I had a go

I started shearin' years ago when I was just a lad.
I was taught to shear by 'The Master', none other than my ol' dad.
I remember the advice that 'e gave me, a memory made to last.
'*E* said, '*Shear 'em close and shear 'em clean and don't try to go too fast*'.
I was never a speedy shearer, but I tried to shear 'em clean,
And I never tried to ring a shed*, if you understan' what I mean.
But I remember a certain day, I guess my resistance was low,
I threw the advice right out of the door and I really 'ad a go.
It was late in September '72 - we were shearin' at Charlie Gregg's.
Flamin' great Corriedale wethers* with wool to the tips of their legs.
There was also a flock of Merino* rams with horns all curls and crinkles,
flamin' great flaps up under their necks and wrinkles on top of their wrinkles.
There were four of us to shear 'em - my pen was number 3.
There was 'Muzza' and Ian Zantuck and ol' 'Bullfrog' Brabham and me.
Now Ian was a very good shearer, and Muzza - 'e wasn't too bad;
but Bullfrog, 'e was a goer, a sort of a bit of a lad.
'E never did like to be beaten – 'e liked to be out in the front.
'E really could shear when 'e wanted - most days I was not in the hunt.
But the previous night 'e'd been boastin' – really layin' it on thick an' sweet –
like '*Tomorrow we're in the big rough uns and there's no flamin' way I'll be beat.*'
Now, I guess it's a natural reaction when you 'ear someone boastin' like that,
that you say to yourself '*Now I reckon ol' mate, tomorrow you'll know where I'm at.*'
I felt quite fiercely determined - to give 'im a bit of a run,
and I reckoned perhaps I could do it, 'coz I was the son of a gun.
Well the day started out pretty even – the wool comin' off thick and fast,
and I sort of tried to pace myself - I was really determined to last.
When the bell went for mornin' time smoko - we 'ad all shorn exactly the same,
Ian, Muzza, me and ol' Bullfrog – neither one of us pullin' away.
The boss said to Bullfrog at smoko - and I must say I thought it was tough:
'*You don't seem to me to be trimmin' their legs and you're leavin' their 'eads a bit rough.*'
Well Bullfrog jus' looked at him quietly, then replied, '*Well it's all for their sakes.*
They reckon with all this 'ot weather, it could be a bad year for snakes.'
Mr. Gregg said, '*So that's what you reckon, I can see that you really are tryin*',
But I think 'twould be nice if you'd trim round their eyes,
and they'll see where the bastards are lyin'.'

Now this sapped ol' Bull's concentration, well no-one does like to be chipped,
And I noticed when we resumed shearin' – 'is speed was reduced just a bit.
But I seemed to be doin' it easy, the blows comin' in thick and sure
The belly, the neck and the long blow, and the wool rollin' off on the floor.
It wasn't too long it was mid-day, and we knocked off to have us a feed,
And still there were three of 'em even, but guess who 'ad taken the lead.
It happened 'bout half past eleven, when I dashed for a sheep in the pen,
And I just happened to grab me a nice little ewe and I shore 'er in one minute ten.
The others were quiet durin' dinner for what was this tale I was spinnin',
Me who was normally draggin' the chain,
was one sheep in front … and still grinnin'.
Bullfrog said *'So you think that you've got me, well a warnin' my friend if you please,*
Soon we'll be in the Merinos, I'm an expert you know shearin' these.'
Ian laughed: *'So 'e says 'e's an expert – well I reckon that you've got 'is measure,*
Because an X is the unknown factor – and a spurt is a drip under pressure.'
Ol' Bull gave a snort of annoyance and I knew that I'd have to watch out,
For one thing 'e really can't handle, is to be joked with or buggered about.
Back to the sheep and 'e put 'is head down and went just as fast as 'e could
But I was determined to stay out in front- and I really did think that I would.
Afternoon smoko - I'm still in the lead, but Bullfrog is wearin' me down
The pressure is startin' to reach me, my smile 'as turned to a frown.
I know that the next run would test me, for I realised what is to come.
We've finished the Corriedale wethers, and Merinos are never much fun.
It happened at roughly four thirty, I got stuck with a really bad ram,
One of those that is all kicks and struggles – the sort that is not worth a damn.
Its 'orns were as sharp as a needle – its wool was all matted and coarse,
A wrinkly ol' bugger as tough as they come and riddled with thistles and gorse.
I knew ol' Bullfrog was watchin' as I struggled and wrestled and pushed
Then 'e put 'is 'ead down and 'e went 'round me
and into the catch-pen 'e whooshed.
Well it was not nice to relinquish – but I knew I 'ad given my best
And I know ol' Bullfrog's resistance 'ad surely been put to the test.
We 'ad each shorn two hundred and twenty
- but our moment of truth was to come,
Because while we were watchin' each other, bloody Zantuck shore two twenty one.

- Geoff White

- Ring — 'fastest shearer'
- Ringer — 'the man who shears the most sheep'
- Corriedale — 'cross-bred progeny of Merino and Lincoln sheep'
- Wether — 'castrated ram'
- Merino — 'sheep variety originally bred in Spain'
- Blows — 'powerful shearing strokes'

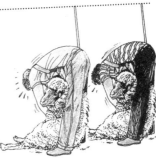

Practise what you preach

In the 1970s I was present at a meeting of the Fern Tree Progress Association when the matter of speeding on the Huon Road was discussed. A resolution was passed to write a letter to the police about the matter. A few days later the police set up a speed trap on the old Huon Road and the first three people booked were: The President, The Secretary and The Treasurer, in that order. This sounds incredible, but it is the gospel truth. The president's name was Dicky Bird and he got a bit chirpy after he was fined.

Bushfire Stories 'Black Tuesday'

The bushfires on 7 February 1967 (known as 'Black Tuesday') burnt approximately 270,000 ha of Southern Tasmania. Extensive areas of Mount Wellington were burnt - from bottom to top. The total damage for the state was: 1,300 houses and 128 major buildings were destroyed in five hours and 62 people died. The damage bill became the biggest insurance payout in Australia's history at that time. The recent Victorian fires on 7 February, 2009, ironically on the same day 42 years later, had treble the fatalities but around the same property damage. Desolation was everywhere at my old home town of Fern Tree: piles of destroyed houses, no greenery anywhere. Every tree on the mountain had burnt, most of them beyond redemption, and in fact, most of the flora and fauna on Mt Wellington was destroyed. Just visualize Fern Tree without fern trees. Also try to picture life without dogs, cats, birds, possums or wild life of any kind, not even snakes.

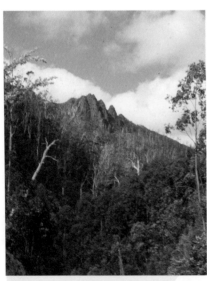

Cathedral Rock before the fires

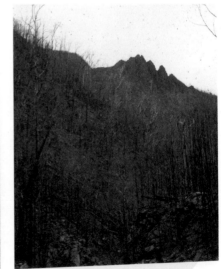

Cathedral Rock after the fires

It was eerily silent for many months. All of the cabins and huts on the mountain were destroyed and only a few have been replaced. Several old disused and long-forgotten tracks were found. Except for the church, all of the major public buildings at Fern Tree were destroyed; including the boarding house, the pub, the shop, the fire station, the pre-school and two community halls. Every power pole on the Huon Road was destroyed so the power was off for six weeks and residents had to cook by the fire. Clothes had to be washed by hand in a trough and there were no hot baths or showers, Residents washed out of a dish. Imagine what it was like with no record players functioning and no TV and radio broadcasts. Lighting was a mixture of smelly kerosene lamps and candles. It was a long six weeks before power was finally restored to Fern Tree and its environs.

Opportunity Lost

After the 'Black Tuesday' bushfires, the Fern Tree Progress Association met frequently to discuss how to rebuild the village centre. A man called Stephenson was the visionary president of the Association and he strongly recommended that all the public and private buildings should be rebuilt in an alpine theme. There was unanimous agreement on this proposal but unfortunately, every public building was planned by a different architect who each had different interpretations on 'alpine'. Generally speaking the public buildings were the first to be erected and it was difficult to recognise a common theme and a hotchpotch of designs resulted. After that, residents lost interest in the concept and rebuilt their houses along conventional designs. If Fern Tree had utilised a single architect for the rebuilding process, the result would have been a township similar to the attractive Swiss village of Grindelwald north of Launceston. The whole district would have prospered as visitors and tourists would have flocked to the town, particularly after a snow fall. The tavern, shops and cafes would have flourished with the increased activity and put the village on the map. Alas, it was not to be.

Bushfire experiences of the author's family

At 1.30pm on the day of the 'Black Tuesday' fires my wife Pauline rang me at work in Hobart to say that police had advised her to vacate our house at Fern Tree as the area was in grave danger from bush fires. Before she left the house, Pauline asked me to pick up our two eldest sons Glenn and Craig from South Hobart Primary School at the foot of Weld Street. There was no time for Pauline to gather up our prized possessions. In fact, all residents had to leave with whatever clothing they were wearing. As it was fiercely hot, people were not wearing much. My conservative sister Bev was wearing a one-piece swimming suit. I have never before or since seen Bev in bathers.

Pauline's story

Pauline and our baby son Zane (18 months old) were driven with other evacuees to the *Fern Tree Hotel* on the back of a truck. When they reached the pub, many panic-stricken residents were gathered at an assembly point in front of it. Some evacuees parked their cars at the quarry just south of the pub. Others parked in Summerleas Road near the assembly point for evacuees where they watched helplessly as their cars exploded in the heat and then burnt fiercely. Around twenty cars were burned out in this way. Flames leapt the road at the Pillinger Drive junction and burnt a paddock on the northern side of the pub. Later on, residents were herded into this burnt paddock as it was the only safe place left. The refugees couldn't go to Hobart because trees and hydro poles had fallen across the Huon Road. There was no panic or visible signs of fear as most of the evacuees were numb with shock.

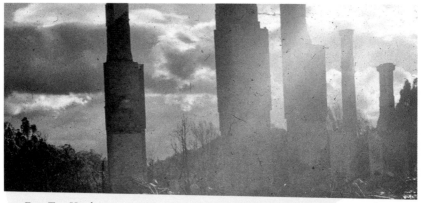

Fern Tree Hotel

The refugees watched anxiously as the surrounding public buildings went up in flames one by one, with some of the menfolk doing their best to subdue the flames. It was probably a hopeless task in roaring gales as the water pressure would have been low or perhaps even nil. When the pub caught fire around 4.30 pm, the police decided that it was not safe to remain any longer, and people just had to evacuate and try their luck on the Huon Road to Hobart. Residents were herded onto the back of some local trucks. The pre-school teacher Mrs. Redmond was requested to remove her stretch trousers as they were inflammable and she did so without demur. In times of crisis there was no time for modesty. To make matters worse, there were no wet blankets available to pull over passengers for privacy or to shelter them from flying sparks and embers. Evacuees on the trucks had a scary ten kilometres drive to Hobart on the winding old Huon Road, through fire, flying embers and smoke. Pauline must have been numb or stunned, as she now has no memory of seeing any burning houses during the trip. Subsequent trips revealed that there were many. With great relief, the evacuees were finally ushered into the safety of the Hobart Town Hall.

My story

After Pauline was evacuated, I caught a trolley-bus from central Hobart to South Hobart to pick up our two sons from South Hobart Primary School, located in lower Weld Street near the Hobart Rivulet. It was eerie on board the bus travelling up Macquarie Street. It was hot and hard to breathe as the air was full of smoke. Visibility was extremely low, the traffic lights were different colours to the usual red, amber and green. As the smoke intensified, the bus driver could not see well enough to continue. He ordered us off the bus at Molle Street, barely half way to my destination. I left the bus and walked up Macquarie Street towards the school. There were hardly any people around. I did see two or three men playing hoses onto their paling fences or under the eaves of their houses. Looking to my right towards Knocklofty, I could see through the smoke that there were several houses on fire in Forest Road. I then realised that we had a real crisis on our hands.

I could see a bright glow in the general direction of the school and I began to fear the worst. When I finally got to the primary school it was deserted and had obviously been evacuated. I could see something on fire beyond the school which was later proved to be the Cascade Brewery. This accounted for the glow in the sky I had seen earlier. A resident near the school told me the kids had been marched away but he didn't know where. I later discovered that the kids were taken up Weld Street to Davey Street (one of my kids lost a shoe in this trek). They then walked down Davey Street to the sanctuary of Anglesea Barracks. I walked back down Macquarie Street to town and noticed that even more houses were on fire in Forest Road. It was a numbing sight. I asked everyone I met if they had seen kids marching down the street. No one had [because they went down Davey Street], but someone suggested that I should contact the RACT, so I went there.

At RACT (then in Macquarie Street), all staff were busy answering frantic phone calls and it was some time before someone was available to speak to me. I overheard a hysterical woman screaming at an officer that her parents were trapped in MacRobies Gully. The narrow MacRobies Road was the only way in and out. It was closed as it was engulfed in fire and was too dangerous to negotiate. Another lady was frantically trying to find out what happened to her sister. The office was in panic-stricken chaos with officers kept busy answering countless phone calls. From what I had seen with my own eyes and deduced from the hysterical pleas of people visiting the RACT, I soon realised that the entire city was in danger of being engulfed by the fire. Finally I managed to speak to someone at RACT and they told me that they had no idea where school kids would be taken for refuge. They had been trying to get information from the police but all the emergency services phone lines were jammed.

I rushed back to my workplace at *The Mercury* to warn them that their building was under threat and to put all important records in a safe place. However, everyone was busily going about their work, blissfully unaware that the fringes of Hobart were burning or surrounded by fire. I stressed that they should let the staff go home to check the safety of their houses and family. My urgent pleas to safeguard records and staff were ignored and I was greeted by complete calmness.

I was only a young man and they probably thought that I was exaggerating the danger. The editorial staff of *The Mercury* wouldn't believe that southern Tasmania was in crisis. The newspaper had the scoop of a lifetime on their hands but didn't know the full extent of it until a day or two later.

At 4.30 pm I tried to ring the police and the Education Department to try to track down my wife and kids but all I got was engaged signals. All the lines were jammed. I rang the Fern Tree shop to get information, but the line was dead. I rang my parents' home but the phone was dead. I rang my sister's house at Fern Tree and got a ringing tone. For curiosity, I rang my own home and got a ringing tone. From this, I deduced that my parents' house and the shop had burnt down and that my sister and I were lucky. I still had to track down my kids so I ran to the Hobart police station and once again I had to wait for some time until somebody was available. It was one of those days when the only person in a hurry was me. When I at last spoke to a policeman he had no idea where my kids were, or where my wife might be. He suggested that I should try either the City Hall or the Town Hall as they would be logical refugee centres. By this time it was around 5.30 pm. I tried the Town Hall first and I was delighted and enormously relieved to find my wife and my swim-suit clad sister there.

Pauline told me a neighbour had picked up the kids from the barracks and that they had been taken somewhere safe. I will always remember the sight of hundreds of people crowded into the Town Hall. They were all dressed in a strange array of summer clothing as it was still unbearably hot. Everyone was anxious, as some people didn't know if their relatives and houses were safe. My mother wasn't there; she was visiting her sister at Glenorchy and she was blissfully unaware of the crisis. My stepfather didn't arrive at the Town Hall until around 7 pm and he had seen his house and most of the public buildings burning and this must have been a horrifying sight. Like many other volunteer firemen that day, he had been too busy helping other people try to save their homes to worry about saving his own home and family.

I told Geoff Baker, my brother-in-law, that his house and mine seemed to be still OK as the phone lines were still alive. At 8 pm we decided to go home and check our houses and stay there all night (if they were still there). Our families had already decided to stay overnight with relatives while Geoff and I drove to Fern Tree in Geoff's car.

I will never forget that eerie drive home. Everything wooden was on fire; trees, hydro poles guide posts, fences etc. The mountain looked magical, all lit up with miniature lights like a Christmas tree. The police had closed the road just past South Hobart but we managed to drive around the unmanned barriers. Geoff drove straight to his place on Grays Road, and found that his house and the house next door were the only two houses on the road to survive. He stayed there to keep his eye on flying sparks. I walked to my home near the foot of the road and I was immensely relieved to see that my house and Sid Williams' house next door were still intact. However, Marty Daley's house on the other side of my block had burned to the ground and sparks were still flying.

Fortunately, the wind was now gusting from the west and the sparks were blowing away from my house.

Amazingly, my garden hose was still functional and I did my best to put out the embers of my neighbour's burnt house. My house was saved by a hedge of exotic, non-inflammable plants between my house and my unfortunate neighbour's property. My house was white and painted with water-based paint, and this combination probably saved it. Sid William's house on the other side of mine had survived, even though it was 'painted' with inflammable black sump oil, except for the gables which were painted with a bright daffodil yellow oil-based paint. Sid had been painting the gables of his house when he was forced to evacuate.

He left his back door open and the opened can of oil-based paint on his back ramp. If one spark had landed inside the paint tin, his house would have burnt, and as our borders were close together, mine would have burnt as well. I had firewood stacked beneath my ramp. One spark would have set it on fire. I was lucky; very, very lucky.

Black Tuesday was the most extraordinary night in my life. Everywhere was devastation; the smoke was pervasive and I was worried about flying embers igniting my house. It was quite windy all night and the sound of burnt or dead leaves blowing onto the galvanised iron roof sounded something like a hail storm.

I didn't sleep much that night and I was immensely relieved to still have a home the next morning.

The township of Snug got all the media attention, but I believe that Fern Tree was the worst hit area in Tasmania on Black Tuesday. Overall, 112 homes in the district were burnt to the ground and in the worst hit area along Pillinger Drive (Pinnacle Road), only nine houses survived out of sixty. My house and my neighbour's were the only two houses to survive on the bottom side of the Huon Road for a kilometre on either side of us.

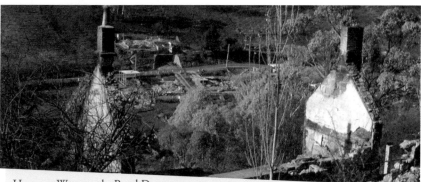

House at Waterworks Road Dynnyrne

Some strange anomalies occurred: Les Daley was digging spuds on his farm when the fires arrived. He wet a potato bag and lay down between two raised up rows of spuds and pulled the bag over him. The fire went right over the top of him and he survived. The publican helped to save the church and succeeded. The minister helped to save the pub and he failed.

Conclusion: God is more powerful than Satan.

Tall stories

Can you beat this?

In the 1950s potatoes were in big demand from Tasmania's North-West coast which was renowned for its huge spuds. Two brothers Bill and Dave lived on neighbouring farms and they frequently tried to outdo each other when they had a few beers together. Here are some examples of the outlandish claims they made:

Bill: *'How did your spuds turnout this year, Dave?*
Dave: *'Pretty good, Bill. I got an order from town the other day for a hundred-weight of spuds, but I had to tell them that I wouldn't cut a spud in half for anyone. How's your's?'*
Bill: *'My crop is fantastic, Dave. I'll save heaps of money as I won't have to buy bags this year. I'll just brand the spuds and send them away.'*

The same rivalry applied to their dairy cows.

Bill: *'How are your new Friesian heifers turning out this year?'*
Dave: *'One calved the other day and her bag is so big that I have to milk one side and then go around to the other because I couldn't reach across. How's yours?'*
Bill: *'Pretty good, Dave. I have one that I have to milk her back teats first or she'll fall back on her arse.'*

Dave had used Clydesdale horses on his farm all of his life. When his son Jack came home from WW2 he bought a tractor, much to his father's chagrin. Dave was having a few beers one sale day at the local pub, when someone asked Dave how his son was.

'Not too good, he's gotta have a big operation,' Dave responded with a frown.
'Oh is his hernia playing up?'
'No, he'll have to have that tractor seat extracted from his arse,'
Dave replied laconically.[21]

21 Advised by Murray Hay 25 February 2009

Ducks and drakes

When you are out duck shooting and someone calls out *'Duck!'* - you should, especially when Jim and Joe are at large. Jim and Joe were shooting one day sitting in a boat on a duck hole surrounded by trees in the Huon district. They were soon lucky enough to see a flock of ducks approaching and the gleeful hunters began to shoot with gay abandon. They had bagged a dozen or so ducks when they ran out of ammunition. Jack went to a box at the back of the boat to get some more ammunition.

'Jeez Joe, you brought the wrong bloody box, this one's full of apple-case nails,' Jack complained bitterly.

'She'll be right Jack,' Joe replied laconically. *'Just ram some powder into the barrel and pour a few nails in. That should do the trick.'* Jack did as his mate suggested and he was amazed when Joe's ploy worked. The two hunters let fly at a flock of ducks flying in front of them and soon they had a bag of birds.

'Well, we've got plenty now, Jack,' Joe eventually declared.

'Did you bring a hammer with you?'

'What do you want a hammer for?' Jack asked in a puzzled voice.

'Well mate, we'll need a claw hammer to get the birds we've bagged off the trees.'

Chapter 9 Bushrangers

The Brady Bunch held up the town

One of the most astonishing and outrageous tales in the annals of
Tasmanian history occurred at Sorell on 3 December 1825 when
Matthew Brady's gang of bushrangers held up the entire town.
As a prelude, Brady's gang of eight men had just raided *Thornhill*
farm owned by R. Bethune. The gang dried themselves before a
roaring fire after a day of heavy rain. They then enjoyed a hearty
meal at Bethune's expense. At 10 pm Brady advised his eighteen
thunderstruck captives that he proposed to march them to Sorell
to put them in gaol after releasing all of the prisoners in custody.[22]

When the group reached the township, four of the gang
stormed the gaol. Brady's captives were then forced inside the gaol
to be guarded by four members of the gang. Laing, the governor
of the gaol, lived in a detached cottage nearby and the sixteen
soldiers making up the town's military force were quartered
nearer to the gaol. The soldiers had spent a miserable day in the
bush looking for the Brady gang in pouring rain and they were
happy to relax near the fire to have a snooze or play card games.
Consequently, there was no one on guard duty when Brady and
his three accomplices burst into the barracks. The bushrangers
stood between the thunderstruck men and their guns and they
were captured with barely a whimper. The vanquished soldiers
were then marched to the gaol to be locked up with the other
prisoners who had refused to be liberated by Brady.

Laing, the governor of the gaol, ran to Gunn's quarters to advise
him of the outrage taking place. Gunn, the commanding officer of the
soldiers, was highly embarrassed that just four men had so easily captured his
entire complement of sixteen soldiers. He dashed into the street brandishing his
double-barrelled gun and was met by outlaws Murphy and Bird who were in
pursuit of Laing to 'destroy' him. Gunn raised his gun but he was shot in the chest
and his right arm was shattered before he could fire. He fell to the street and the
bushrangers left him for dead, thinking that he was Laing.

Two town men named Scott and McArra exchanged shots with the bushrangers
and McArra had his wrist broken by a bullet. After a couple of minor scuffles with
curious residents, the outlaws made their escape after locking all the doors of the
gaol. Before they departed they erected *'a stick with a great coat and hat upon it, to
imitate a sentry at the gaol door, in order to gain as much time as possible.'*

22 This appears to have been to settle a grudge against Laing the gaoler

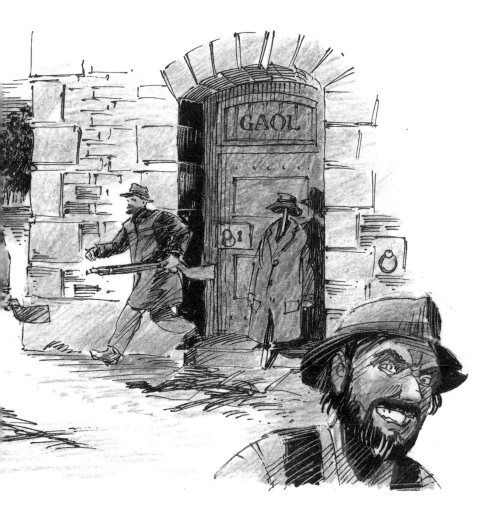

Although Gunn survived being shot, he lost the use of his right arm and from that time on he became irreverently known as 'Wingy'.

Naturally, after this ignominious event, there were many accusations, witch-hunts and embarrassing questions asked of Gunn, the soldiers and local police. One wonders why nobody has had the foresight to create a light comedy show or a film of this action-packed farcical affair. It would be hilarious – like the *Keystone Cops* or a *Benny Hill* episode.[23]

23 Further reading: *Brady Van Diemen's Land 1824-27* (James Calder text of 1873) pp 81-84

Marshal Beamont meets bushranger Brady

Bushranger Matthew Brady had a reputation of being a 'gentleman' and this was graphically illustrated in the following astonishing story:

One hot summer day in the mid 1820s, Provost Marshal John Beamont was riding his horse through the Hamilton area when he dismounted at a stream to quench his thirst. As the lawman lay on his stomach drinking, his horse took off *'with the marshal's saddle-bags, pistols, and everything, leaving the rider to finish his journey home on foot.'* Beamont fruitlessly pursued the bolting horse as he was in a precarious situation with no food, guns or ammunition to defend himself in an area heavily populated with Aborigines, sheep stealers and bushrangers. He resigned himself to continue his journey on foot but he soon found it difficult to walk in his riding boots. He became lame and weary after walking several miles, but he hobbled along until he came across a camper's tent erected in a secluded spot. Beamont looked inside the tent, and found a 'nice-looking' young man sleeping. Suddenly the man became aware that he had company and he bounded to his feet and bolted past Beamont and picked up a gun resting against a nearby tree. The camper pointed the weapon at the startled marshal and the conversation went something like this:

'Grabbed at last by God!' the man exclaimed when he recognized the marshal who was the person responsible for imposing sentences on bushrangers when they were brought to justice.

'Not by me at any rate,' Beamont replied nervously realising that he could expect no mercy from this man. However, Brady quickly realised that the bedraggled man was no threat.

'Why ... Mr. Beamont ... where are the rest of your party? What brings you to my camp?' Beamont explained his predicament and then curiously asked how the man knew his name.

'I'm Brady the bushranger,' the man replied. *'I've seen you before, but I don't suppose that you remember me. Anyhow, if you are lame and you have lost your horse I will lend you mine as you can't remain here. Otherwise, you'd be dead meat when my men get back.'* Beamont was astonished and relieved by this kindly gesture and he gladly mounted the proffered horse and rode off, with the bushranger trotting at his side. Both the bushranger and his possible future executioner chatted away amicably as if they were old friends until they came in sight of the New Norfolk watch-house. Brady calmly asked Beamont to dismount and return his horse as *'it was not quite convenient, [for me] to accompany you any further, at least in **that** direction.'* When Beamont dismounted, the bushranger coolly mounted the horse. He wished the marshal *'good afternoon'* and galloped off to meet the rest of his gang at the campsite.[24] As it transpired, it was not Beamont, but Justice John Pedder who eventually sentenced Brady to death in 1826. One wonders, if Beamont had still been in power, whether he would have spared Brady, in gratitude for his kind act.

24 Further reading: *Brady Van Diemen's Land 1824-27* op. cit. pp 1, 77-78

Pearce the cannibal - the real story

Prepare yourself for a ripping but grisly and horrifying yarn. The escape on 20 September 1822 from Hells Gates of convict Alexander Pearce (1790-1824) and seven companions is one of the most desperate, ambitious, infamous, macabre, distorted and misreported epic tales of survival in Australian history. The eight escapees were Pearce, Robert Greenhill, Thomas Bodenham, William Kennerly, Alexander Dalton, Matthew Travers, William Brown, and John Mathers. They proceeded overland and the following summary is a probable outline of what *actually* occurred:

After fifteen days on the run and their provisions exhausted, it was resolved that someone had to die to feed the famished party. Rather than risk being murdered and eaten, Brown and Kennerly returned to Macquarie Harbour, only to die of exhaustion in the prison hospital a few days later. The other group continued their arduous trek but they were murdered one by one with Greenhill's axe to sustain the remainder. Finally only Pearce and Greenhill were left until Pearce despatched Greenhill, to become the sole survivor. Three days later Pearce emerged in familiar territory in the highlands and he eventually joined up with bushrangers William Davis and Ralph Churlton for a couple of months. The trio were arrested at Jericho by a party from the 48th Regiment and taken to Hobart Town gaol on 11 January 1823 where Churlton and Davis were tried and executed in April. Pearce's evidence was not believed and he was returned to Macquarie Harbour in 1823 to serve out the remainder of his sentence, working in irons.

Convict Thomas Cox kept urging Pearce to help him escape from Hells Gates and eventually this occurred on 16 November 1823. Five days later Pearce surrendered by sending a smoke signal to pilot James Lucas who had been patrolling the harbour in his ship.

Pearce confessed to murdering Cox two days beforehand at the King River and to living off his remains. Pearce was tried in Hobart Town 20 June 1824 and he was sentenced to death by hanging *'and that his body when dead be disjointed'*. The execution was carried out on 19 July 1824.[25] After his body was hung for the usual time it was taken down and dissected. The head was separated from the trunk and it turned up 30 years later in a collection of over 1000 skulls assembled by Dr Samuel Morton, an American scientist with an interest in phrenology. Today Pearce's skull minus the lower jaw and teeth may be seen in the museum of the University of Pennsylvania.[26]

Pearce had been at large for nearly four months, but half of this time was spent with bushrangers and shepherds on the fringes of the settled districts. Pearce has the dubious distinction of being the first white man to cross the west coast mountains and to traverse the island from the west to the Central Plateau. If it

25 Further reading: *Alexander Pearce* (Dan Sprod) Cat & Fiddle Press Hobart 1977 pp 61-123
26 Further reading: *Great Escapes by Convicts in Colonial Australia* (Warwick Hurst) Kangaroo Press Sydney 1999 p 490

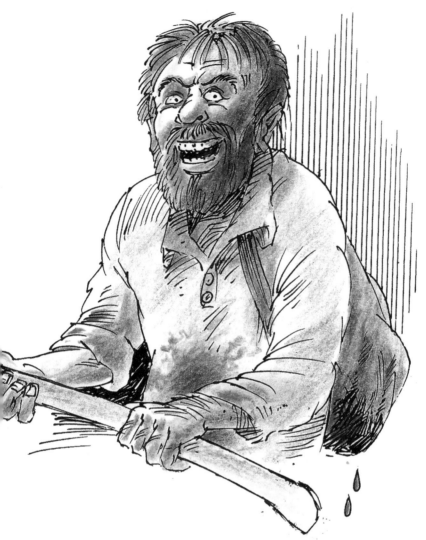

were not for the fact that Pearce was a cannibal, he would have become acclaimed
for his epic overland trek. When asked why he resorted to cannibalism Pearce
replied – *'No man can tell what he will do when driven by hunger.'*

His answer implies that Pearce was not the monster that he has been portrayed.
Scandalous stories about Pearce drinking human blood, making pies with human
remains and selling arsenic-laced pies in Hobart are just macabre fabrications.
Because of sensationalist news articles accusing Pearce of *'feasting on human blood,'*
an early map of Van Diemen's Land records the South-West wilderness area as
'Transylvania' (after the home of Dracula).

NB Despite popular belief, Pearce was not 'The Pieman' after whom the Pieman River is
named (see next article).

The real Tommy 'The Pieman'

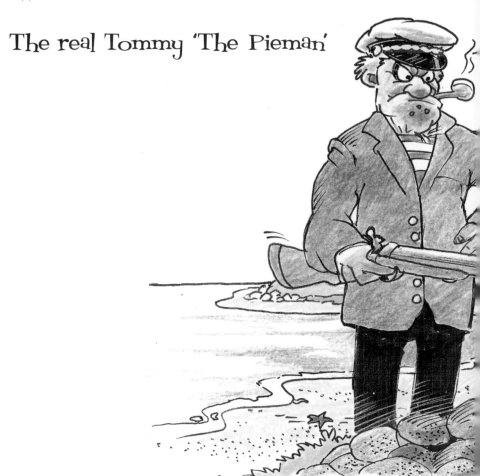

According to a much-repeated myth, the Pieman River was supposedly named when 'Jimmy the Pieman' (some reports say Alexander Pearce) was captured at the mouth of that river after escaping from Hells Gates. However, the truth is that Edward O'Hara and Thomas 'Tommy the Pieman' Kent (a convict baker who was only 4'11" tall) escaped from custody at Hells Gates on 22 December 1822. The Macquarie Harbour pilot James Lucas set off up the west coast in pursuit of them, expecting to find them at the Retreat River. As a consequence, he changed the name of the Retreat to the Pieman River. However, the two men escaped Lucas' clutches by rafting the wide mouth of the river. The Pieman's escape was three months after Alexander Pearce absconded and the two events have since become confused and interwoven. The escapees Kent and O'Hara were picked up just beyond Cape Grim and taken to George Town in a sloop owned by James Parish. Kent and O'Hara have the distinction of being the first white men to have walked from Macquarie Harbour to Robbins Passage. Kent left George Town and then found his way to Hobart Town and continued to get into trouble until he was again returned to Macquarie Harbour in July 1824.

By an amazing coincidence he was sentenced in the same sitting of court as Alexander Pearce who is often portrayed as 'The Pieman' (see previous article).

Kent again escaped from Hells Gates, this time with Robert Cowbarn and they went southwards and were apprehended at Port Davey and sent on to Hobart Town. Once again Kent was returned to Macquarie Harbour and he eventually found himself serving time at Port Arthur. This time Kent had the distinction of being the first recorded white man to have walked from Macquarie Harbour to Port Davey. Combining his two escapades, Kent had walked the entire west coast of the island, a remarkable achievement considering that he had neither map nor compass. Today we laud many other pioneer trekkers like Burke and Wills, but we do not recognise similar feats of daring and endurance by our convicts. 'Little Tommy' Kent lived the final years of his life as a respectable citizen of Launceston.[27]

27 Further reading: *Alexander Pearce* (Dan Sprod) op. cit. pp 113-115

Head-hunting – tails you win, heads they lose

Warning: If you dislike blood and guts, **don't** read on.

The first recorded bushrangers in Van Diemen's Land were John Brown and Richard Lemon. Both of these men were believed to have a record of murders in NSW before arriving in Van Diemen's Land. Shortly after arrival, they captured and executed three soldiers from the NSW Corps (Corporal John Curry, Private Grindlestone and Private Daniels). They then began a reign of sheer terror from 1806-8 which led to the government offering a reward of £50 for their capture dead or alive. For a time Brown and Lemon joined a party of eight absconders from Hobart Town, but the latter were so disgusted with the bushrangers' excesses that they tied the two men up and left them bound in the bush. Somehow they escaped and continued their life of crime with another outlaw named Scantling. Brown and Scantling often conversed in Gaelic and this so incensed Lemon that he killed Scantling near Oatlands at what was later named Scantlings Plains. Macquarie indignantly renamed them York Plains (after the Duke of York) on 5 December 1811 to obliterate the convict stain. The outlaws were also accused of murdering convict hunter R. Scandon, but this may well have been a misspelling of Scantling. One grisly version of Scandon's death (probably apocryphal) suggests that he was bound hand and foot and tossed into a fire to burn to death.

Lemon and Brown were brought undone by bounty hunters Michael Mansfield, James Duff and John Jones for the £50 reward. Mansfield tricked the bushrangers into believing that he was an ally by promising to get some supplies for them. He returned with two bottles of rum but maintained the supplies had become too heavy and he had hidden them nearby in a hollow tree. Brown and Lemon consumed the rum and lay down to sleep at their camp just south of Oatlands (later named Lemon Springs). In the early morning of 1 March, 1808 Mansfield waited until he heard the outlaws snoring before he quietly removed the flint from their guns. He then fatally shot Richard Lemon in the head with one of his own pistols. Mansfield then turned Lemon's second pistol on to the cowering Brown and held him captive until his

accomplices arrived and tied him up. A condition of the reward system in those early days was that claimants had to prove the identity of any bushranger captured or killed. This was usually achieved by bringing the bandit or his head to Hobart Town to be positively identified by the authorities. Lemon's body was decapitated on the spot and the unfortunate Brown was compelled to carry his mate's head in a tied sack back to Hobart Town so that Mansfield could claim the reward. On arrival at the Derwent they handed Brown to a guard and the rest of the party travelled to Hobart Town to show the grisly contents of the sack to Governor Collins to claim their reward.

Brown was sent to NSW for trial, sentencing and execution. Brown appeared to be penitent prior to his execution in Sydney.

At that time brutal murderers were subjected to the additional ignominy of dissection for experimental purposes and the public exposure (i.e. gibbeting) of their decaying bodies.

Lemon Springs must have had bad vibes, because in 1826 Captain Whyte of the ship *Duke of York* shot himself here by tying his foot to the trigger of his gun. Whyte was depressed at the time as he had seized the ship *Caledonia* and was subsequently reprimanded and lost his command.

Two bushrangers Birkett and Perry killed George Kelsey near here in 1853 by using a shear blade with a wooden handle attached.[28]

28 Further reading: *The Tasmanian Gallows* (Richard P Davis) Cat & Fiddle Press, Hobart 1974 p 3; *A History of Oatlands and Jericho* (KL Von Stieglitz) Telegraph Printery, Launceston pp 12-14

The not-so-great escape

Port Arthur was regarded as 'escape proof' as escapees by land had to negotiate rugged terrain usually with no map or compass to guide them. In addition the area had few creeks to provide fresh water. The authorities deliberately propagated a story that the seas around Tasman Peninsula were infested with sharks and sea monsters to deter escapes by swimming. Escapees also had to cope with two heavily-guarded narrow necks to reach the Tasmanian mainland. Another more tangible deterrent was the presence of eleven large 'ferocious' guard dogs chained in a line at Eaglehawk Neck. If the dogs didn't get you the sentries at the line would. Nevertheless, there were many attempts to escape Port Arthur, but very few of them were successful. The most renowned escape was that of Cash, Kavanagh and Jones who remained at large for several months. Martin Cash is purported to have absconded from Port Arthur four times and Cashs Lookout overlooking Eaglehawk Neck commemorates one escape. Most of the absconders who made it past Eaglehawk Neck were captured elsewhere on the Forestier Peninsula and were subsequently returned to Port Arthur. They then told their friends about the countryside they had covered and location of sentries and the information facilitated further escape attempts.

One of the more ludicrous escape attempts from Port Arthur occurred when a convict named Billy Hunt dressed himself in a kangaroo skin and managed to elude the dog line at Eaglehawk Neck (probably by swimming across Pirates Bay). A soldier on duty saw a huge forester kangaroo bounding towards Forestier Peninsula and he said to his mate, *'I think I will have a shot at that big boomer'* (forester kangaroo).

Billy Hunt must have heard the comment and he surprised the soldiers by throwing off his disguise and crying out *'Don't shoot, I am only Billy Hunt.'* [29] The 'bounder' Billy, minus his kangaroo skin, was returned to Port Arthur hopping mad, where he became a laughing stock for many years thereafter. Today he would have earned the nicknames of 'Skippy' or 'Bouncing Billy'.

In his younger days Hunt was a mountebank (a hawker of snake balms and health elixirs) in order to deceive a gullible public. The kangaroo skin disguise was in character with his former occupation. Jumping kangaroos, what a great story!

29 Further reading: *The Penal Settlements of Van Diemen's Land* (Thomas James Lempriere) written 1839, reprinted by Royal Society Launceston 1954 p 69

The great escape

The most celebrated escape from 'escape proof' Port Arthur took place on 13 February 1839. An audacious plan to steal the Commandant's six-oared whaleboat was hatched up by Thomas Walker and seven fellow convict boatmen. As the boat sheds were patrolled heavily by night it was resolved to steal the boat when least expected, in broad daylight around 10am. The plan was put into operation and no one saw anything remarkable in the usual boat crew boarding the Commandant's whaleboat, and they were well out into the harbour by the time the authorities realised that something was amiss. Commandant Booth had been tipped off that an escape by boat was imminent and he was highly embarrassed that the escapees were his personal boat crew and they had chosen to escape in his own boat. He hastily selected another boat crew to pursue the runaways who by then had a 2 kilometres start. As soon as the runaways were in open water, they hoisted all the sail they could muster and they sailed effortlessly away.

By the time a pursuit was mounted from Hobart the authorities had no idea where to look. The escapees landed at Adventure Bay and stole some guns, ammunition and provisions from a whaling station and then set sail for Southport where they raided another whaling station. They were incredibly polite and non-threatening and they shrewdly told the whalers that they were headed for Cloudy Bay on South Bruny. They sailed in that general direction until they were out of sight of the whalers and then set sail at all speed around the south coast and headed for Port Davey.

In the meantime, reports of the two robberies filtered through to Hobart and the Port Officer Capt. George King set sail in the fast government ship *Eliza* with a boatload of soldiers. Another ship the *Isabella* was despatched from Port Arthur to search the Channel should the runaways head in that direction. King assumed that the escapees would make for the now abandoned Macquarie Harbour where ships like the *Eliza* could not enter with safety. Therefore, the plan was to catch the runaways before they could reach Port Davey. However, the escapees had anticipated a pursuit and Walker hid the whale boat at Foxes Cove [Cox Bight?] and the prisoners were rewarded to see the *Eliza* sail past. The *Eliza* searched fruitlessly all around Port Davey looking for the escapees. The skipper warned Henry Brooks, a shipwright at Port Davey, to be alert for the runaway party. Walker and his group remained hidden and waited until the *Eliza* returned from Port Davey. When this occurred and the ship was out of sight, the gang set sail for Port Davey knowing that they would not be pursued.

When the *Eliza* returned to Recherche Bay the *Isabella* was in port. The crews of both ships were totally confused as to where the escapees could have gone. Another ship the *Shamrock* was despatched from George Town to search for the escapees down the west coast of Tasmania while a group of soldiers on foot searched the land on Bruny Island in the Cloudy Bay region (see the next item for a continuation of the great escape).[30]

30 Further reading: *Escape from Port Arthur* (Ian Brand) Jason Publications W Moonah 1978 pp 16-35

The gun-fight at Port Davey

We now continue our riveting story from the previous article. The eight escapees from Port Arthur penitentiary sailed into Port Davey on 25 February 1839 and went ashore and demanded provisions at Henry Brooks' shipyard camp, at what became known as Brooks Reach (aka Brooks Bay). The shipyard was sited in this wilderness location to utilise the Huon pine in the Davey River region. Brooks had anticipated the visit and he wisely gave the bushrangers some supplies to get rid of them quickly, even though the desperadoes had stolen a duck gun, a shot belt and some gunpowder from shipwright Downie. The gang sailed off and probably hid in the safe environs of abandoned Macquarie Harbour. They returned a month later and they quietly purloined some more stores but they were discovered loading their haul into their whaleboat. This time shipwright Henry Brooks was prepared for them as his report reveals.

'On 20th March last about 8pm, I saw the prisoner Walker, and I heard the voice of Jones at my place; I had just finished tea in company with Mr. Downie when a servant of mine came in and said, the bushrangers had come again. The first thing Mr. Downie and I did was to secure the arms which consisted of 5 or 6 muskets which I had shown Walker on his previous visit, and which since that time we had got the smith to repair, so they would all go off. We also had an old blunderbuss, and a double-barrelled gun, which they had overlooked on their former visit. … I saw … Birkman … I called to him and he answered me. I asked him if he had any cartridges, he said *'yes'*; I said *'the pieces are loaded with shot, and I will put a bullet in each. … we will go out and fire upon them'*; Birkman said, *'Don't do that,'* and informed me that it was arranged to let them get into the boat. I approved of the plan, and Birkman said *'You'd better show yourself, and then they won't think we are going to take them.'* … As I was going down towards the boat. … I said *'halloo, is that you, do you think that I am going to stand this?'* Walker made some reply, but I do not remember what it was. … I saw several people running away but could not distinguish who they were [in the dark]. I called out to the men in the hut. *'Come out my lads, now is the time to seize their boat.'* I said to Birkman, *'I think we should fire or they will get away.'* We both fired, nearly together. Just after, I observed a piece pointed in a direction towards me. … I saw a flash. … Birkman and I fired another shot each at the prisoners, and then ran down towards the boat. The prisoners all got in … and they got away.'

Although, Brooks' report doesn't say so, the bushrangers fired four rounds at the shipwrights. One of the bushrangers was hit and fell out of the boat but he was immediately pulled in by the others. The prisoners sailed off and made several stops along the Tasmanian east coast to replenish food and water. Each time they stopped they courteously requested food and supplies from settlers until they finally arrived safely at Twofold Bay, NSW where their luck ran out. The most mild-mannered and polite runaways on record were recaptured at Twofold Bay in May 1839. In normal circumstances, an epic voyage in an open boat over several hundred miles, probably without maps and navigation aids, would be celebrated as a heroic feat of superb navigation. Their escape plan was executed to perfection and they had the authorities totally bewildered as to their whereabouts. The desperadoes were returned to Hobart Town to stand trial in June. Walker and Dixon died in Hobart Hospital before they could be tried and another man Thompson was not tried. The remaining five escapees were sentenced to life imprisonment.[31]

31 Further reading: *Escape from Port Arthur* op. cit. pp 36-40, 58-60

The case of the holey hat

James McGiveran was affectionately known as 'Jimmy the Postman' and was one of the colourful characters of the Huon in the mid 1850s. In his role as postal messenger Jimmy used to walk from Hobart to the Huon along the tortuous Huon track that wound around the high foothills of Mount Wellington. Jimmy always believed in making a dramatic entrance to each settlement on his route. Long before he reached a township, he would blow at short intervals on a bugle that could be heard from a great distance away. The settlers welcomed the sound, for they realised that another bag of letters and papers would soon be available to tell them what the outside world was doing. An article written in 1936 by WH Kennedy from stories told to him by elderly resident William Latham records the following fascinating details of this colourful character:

'He [Jimmy] used to carry the mails from Hobart to Franklin on his back making the journey twice a week. His terminus was the *Lady Franklin Hotel*, then conducted by Mr. Tabor, where he would spend a great deal of his time between trips reciting the experiences and hair-breadth escapes which he alleged he had from bushrangers. Jimmy's descriptive powers were second only to his imagination, and he would hold crowds of timber splitters spellbound at the graphic accounts he would give of his skill and daring in evading the bushrangers, who would have been only too pleased to capture 'Her Majesty's mails', if they could. On one occasion he took the breath of his listeners away by proudly exhibiting his hat, which had unmistakably been penetrated by a gunshot, and explained that 'Rocky' [Whelan - bushranger] nearly got him as he was peeping from behind a tree to see in which direction the bushranger was making. His fleetness of foot and skill in bushcraft, he said, got him safely out of danger on the occasion. Some time afterwards, the late Mr. William Cuthbert explained the holes in the hat in quite a different way. 'Jimmy the Postman' had a hut on Mr. Cuthbert's property, and hearing a shot fired one night, he investigated the matter, and found that Jimmy had wilfully punctured his hat with a few pellets from his shotgun, but he never told Mr. Cuthbert the story of the encounter with 'Rocky'.'

The story of Jimmy's deception spread like wildfire and after being exposed as a fraudster, Jimmy was the laughing stock of the Huon for several years thereafter.[32]

32 *Huon Weekly Times Centenary Supplement* Franklin 1936

Chapter **10** Do you know?

Tasmania, Florida

Did you know that there once was a town known as Tasmania in Florida USA? It was formerly a rural settlement along Fisheating Creek that commenced around 1888 and changed its name to Tasmania in 1916. It became a ghost town during the depression when the railway bypassed the area.[33]

Tasman was a failure

Statue of Tasman and his ships *Zeehaen* and *Heemskirk*

The first known European to 'discover' Tasmania was Abel Janzoon Tasman (c1603-1659) who was born in the village of Lutjegast, near Groningen, Holland. In 1642 Tasman was appointed to command two ships *Zeehaen* (Seacock) and *Heemskirk* (named after a famous Dutch admiral). After discovering and charting part of Van Diemen's Land in November 1642 Tasman charted New Zealand, Tonga and Fiji and then north to New Guinea. He was the first known navigator to prove beyond doubt that *Terra Australis* was not a huge continent stretching southward to the South Pole. In 1644 he went on a second voyage and traced Australia's north and west coastline from Cape York to Shark Bay. The Dutch authorities regarded both of Tasman's voyages as failures as he did not discover wealthy lands, new markets or a shipping route to the Pacific (Torres Strait).[34]

33 http://wikimapia.org/11624432/Tasmania-Florida-ghost-town
34 Further reading: *Discovery of Tasmania 1642* op. cit. pp 34-35

Lenah Valley was named because of a new tram service

Lenah Valley was previously successively known as Sassafras Valley, Kangaroo Bottom and Kangaroo Valley. When a new tram service began in 1922 the name 'Kangaroo Valley' would not fit into the destination panel at the front of the tram. Therefore, the name changed to the Tasmanian Aboriginal name for kangaroo which was 'lenah'. This solved the problem. The name of Kangaroo Valley officially changed to Lenah Valley on 30 September 1922.[35] It is interesting to note that the Kangaroo Valley Post Office operated from 1 January 1897-1910. The post office was then downgraded to a mail receiving house from 1910 until July 1921 when it closed for many years. It reopened as Lenah Valley Post Office on 28 June 1948 twenty six years after the district name had changed.[36]

Trevallyn was once known as Nyllavert

In 1825 brewer William Barnes arrived in VDL and c1828 purchased 400 acres of land in Launceston from The Gorge to Cormiston Road for £112. He named his property 'Trevallyn' after a town in North Wales. The Trevallyn Post Office began 20 August 1890 as a receiving house. In April 1937 someone ordered a new rubber post office stamp but unfortunately Trevallyn was inadvertently spelt backwards as 'Nyllavert'. Consequently, from the 1 May 1937 the post office changed its name to 'Nyllavert' until the problem could be fixed. It must have taken some time to fix because the post office retained the backwards name until 31 May 1968.[37] The name of Nyllavert is still retained as a district name in some quarters. However, rest assured that Trevallyn is not a backwards suburb.

Hobart's capital status was once under threat

New Norfolk and later Brighton were once planned by Governor Arthur to be the capital of Van Diemen's Land. The rationale behind this was that Hobart was thought to be too vulnerable to attack from the water by France or other potential invaders. By placing the capital further inland it lessened the chance of invasion from the sea and either place could be a hub to give easy road access from north to south.

35 Further reading: *A History of Kangaroo Valley – Lenah Valley* (Trevor Owen Wilks) self-published Hobart 1995 pp 81, 87
36 *The Post Offices of Tasmania* (AE Orchard) Magpie Publications Hobart 1991 pp 32, 37
37 Ibid. pp 46, 61

Chapter 11 Nomenclature Secrets

Droughty Point

Many people over the years have been mystified at the local pronunciation of Droughty Point as 'Droothy'. This point is located on Hobart's eastern shore opposite to Taroona. Droothy is the Scottish equivalent of the English 'droughty' (meaning 'subject to drought conditions'). Whalers, woodmen and ferrymen cut timber here to fuel their fires over many years and this has denuded the point of trees. The eastern shore of the Derwent gets much less rain than the western shore and consequently the grasslands of Droughty Point are often yellow through want of rain.

The *James Craig* off Droughty Point

Chinamans Beach

This beach on Droughty Point owes its name to an incident after the arrival at the Derwent of the plague ship SS *Lady Montagu* (Capt. JA Smith) on 12 April 1850 The 651 ton ship sailed from Canton via Sumatra with 270 Chinese coolies aboard bound for Lima silver mines in South America. Why it sailed such a strange route is unknown. When the ship left Canton there were 400 coolies recorded as being on board but it would appear that the initial number should have been 440 as the figures don't add up. The ship had a chaotic voyage to Tasmania and was subjected to dysentery, murder, suicide and disease.

During the voyage 170 coolies died and were progressively buried at sea, and as a consequence, the ship was not allowed into Hobart Town and was placed under strict quarantine. It was patrolled regularly to ensure that there was no contact with the shore. Six more coolies died whilst the ship lay at anchor in the Derwent and the bodies were secretly thrown overboard to prevent further infestation on board. The body of one coolie was found washed up on a beach at the tip of Droughty Point and was furtively buried there to avoid panic in Hobart. The beach subsequently became known as Chinamans Beach and is located just south of Tryworks Point on Droughty Point. Stories abound that fishermen had a lean time after this, as residents of Hobart would not eat fish caught in the Derwent for twelve months.[38]

Bridgewater Jerry

The Bridgewater Jerry is a fast-moving Derwent fog and its name origin has baffled Tasmanians for many years. The man responsible was Joe Cowburn, a *Mercury* correspondent on fishing. Joe's early morning fishing sorties became unbearable when the chilling river fog invaded his favourite fishing spots near Bridgewater. With some rather bizarre logic, Cowburn dubbed the fog 'gerrymander' in the 1930s because American journalists referred to the Massachusetts gerrymander* as an 'icy terror and winged monster'. Cowburn began to call the fog the Bridgewater Gerrymander in some of his fishing articles. As 'Gerrymander' was a cumbersome word, Cowburn soon shortened it to 'Jerry' for easier pronunciation and the perplexing name stuck. With some even more confused thinking, Cowburn justified this abbreviation for the 'obnoxious' fog because the word 'Jerry' was a derogatory nickname applied to 'obnoxious' Germans during the World Wars.

* NB The word 'gerrymander' was first coined by the US press to describe a rigged election in 1812 by Eldridge Gerry, Governor of Massachusetts, USA.[39]

> Dick Hicks the popular publican at the *Bridgewater Hotel* in the 1940s once featured a large white jerry-pot concreted into a wall in the pub to create amusement by symbolising 'The Bridgewater Jerry'.

38 *Shipping Arrivals and Departures Volume 3 1843-1850* (Graeme Broxam) Navarine Publishing 1998 p 197, *HTC* 17 April 1850
39 Further reading: *Memoirs of JJ (Joe) Cowburn* (Editors Stanley Cordwell & Rita Cox); DVC Information Centre publication pp 14-15

Chapter 12 Scary

The Bass Strait Triangle

There have been many mysterious and unsolved disappearances of ships and aeroplanes in the triangle formed by Bermuda, Miami (Florida) and Puerto Rico and this became known as the Bermuda Triangle. For the same reasons Bass Strait is sometimes referred to as the Bass Strait Triangle. It began when a number of shipwrecks occurred here in the 1830s before the advent of lighthouses. As a consequence, David Howie was employed by the government to seek out wrecks, get help if necessary and to bury the dead etc. Shipwrecks reduced markedly after lighthouses were built in Bass Strait. Nevertheless, there are several baffling cases of ships and crews disappearing in the strait. Some examples are: Two sealing sloops the *Raven* and the *John* disappeared in Bass Strait in 1806 with the combined loss of around fourteen people. The *Harlech Castle* disappeared with a crew of twenty three in 1870. The steamer *Federal* vanished without a clue in 1901 with a crew of twenty three. The yachts *Charleston* 1979, *Patanella* 1988 and *Great Expectations* in 1990 all disappeared without making mayday calls. These are just a few of the shipping mysteries yet to be solved.

Several aeroplanes have also disappeared in the strait. In 1934 a four-engined aeroplane *Miss Hobart* with twelve people aboard, took off from Launceston bound for Melbourne and disappeared over Bass Strait. Max Price, a very experienced commercial pilot, with Lake Pedder activist Brenda Hean aboard, mysteriously disappeared over Bass Strait in a two-seater Tiger Moth on 8 Sept 1972. Hean had engaged Price to undertake some sky-writing over Sydney with the words *'Save Lake Pedder'* [from flooding]. The plane was expected to refuel at Flinders Island at noon but it did not arrive. An alarm box aboard the plane mysteriously did not activate on crashing. Foul play was suspected as Ms Hean was reputed to have received a death threat on the evening before her departure. The hangar housing the ill-fated plane was broken into that night, but nothing appeared to have been stolen. Perhaps the break-in was planned to interfere with the aircraft?[40]

However, the most intriguing and disturbing disappearance was that of flight instructor Frederick Valentich who took off at sunset in a rented Cessna aircraft from Moorabbin, Melbourne on 21 October 1978 bound for King Island. Eighteen minutes before he was due to arrive at King Island he reported to Steve Robey at Melbourne's Flight Services Unit (air-traffic control) that a long, brightly lit object was *'playing games with his Cessna'*. The following conversation was taped:

Robey: *'Roger, and how large would the, er, object be?'*
Valentich: *'I'm orbiting and the thing is just orbiting on top of me. It's got a green light and sort of metallic like. It's all shiny on the outside.'* The control room checked and found that there were no military aircraft in the vicinity. Robey asked Valentich his intentions and his final words were: *'My intentions are, ah, to go to King Island. Ah, Melbourne, that strange aircraft is hovering over the top of me again…It's hovering and it's not an aircraft!'* After seventeen seconds of eerie silence an unexplained metallic sound marked the end of transmission. Valentich and his plane just disappeared with no trace of any wreckage or oil spills. Federal investigators reported: *'The reason for the disappearance of the aircraft has not been determined'*. Was the strange hovering craft an UFO? How spooky is that?[41] Is there some evil, supernatural or alien force operating here to account for the numerous unsolved mysteries in the strait?

40 Further reading: *What Happened to Brenda Hean* (Scott Millwood)
 Allen and Unwin Crows Nest 2008 pp 9, 10
41 Further reading: *Tasmania to the Letter* (Mike Jenkinson) Magnum Offset, Hong Kong 2006 p 277

The randy ghosts of the George Town signal station

Some Launceston nurses who had visited George Town in 1969 hysterically reported that the old signal station overlooking the town was inhabited by ghosts. Their locked car had mysteriously been moved to another nearby location and four misty figures were seen hovering outside the station uttering eerie shrieks and ghostly noises. After this report, a group from Hobart calling themselves the Independent Scientific Research Organisation set up ghost-busting equipment inside the station but they were disappointed to find no evidence of supernatural presences to support the nurses' scary story.

However, a few years later an author of ghost books unearthed the mystery when he interviewed a local resident who wryly admitted to 'inventing' the ghosts to enhance his lacklustre sex life. This man had heard that some nurses intended to camp for the weekend at the old signal station. Consequently, he and three other red-blooded male co-conspirators hatched up an elaborate ghostly strategy to unnerve the female visitors when they arrived.

The unsuspecting nurses arrived in their small car and cheerfully ensconced themselves safely inside the station building. The four youths waited until darkness set in and they physically picked up the nurses' tiny Mini Minor car and carried it to an unlikely location. Then they donned 'ghostly' disguises consisting of bed sheets and flitted around the building making a lot of eerie moaning and groaning noises until the comely visitors were thoroughly traumatized. When feminine screams echoed from within the 'haunted' building, the four 'white knights' discarded their ghostly disguises and miraculously appeared out of nowhere to 'rescue' the hysterical young nurses from the 'evil spirits' invading the old station. The four extremely friendly 'ghosts' then gallantly offered to '*protect and take care of*' the panic-stricken nurses for the remainder of the evening. How many other ghost stories commenced in this way?[42]

Shaggy dog story

There once was an old two-storey building at Sassafras known simply as the Old Stone House on the Bass Highway near Latrobe. The building became a dilapidated ruin and was completely demolished about 1995. It was a stage coach changing post in the 1860s and during the depression of the 1930s the building earned a reputation for being haunted. The ghost was apparently that of a miser who lived here, who was strangled by an intruder looking for his gold. The murderer was never apprehended. As the building fell into disrepair, it became a Mecca for young men who went there at night to prove their courage.

42 Further reading: *The Ghost Guide to Australia* op.cit. pp 326-327

A historian reports the following misadventure of one such intrepid young man:

'At the height of its ghostly fame, a young man with his dog drove up to it [the house] one night in a car which he left standing beside the road.

The dog was left on guard in the car whilst the young man went around to the back of the house and managed after some difficulty to open the door and mount the stairs to the second storey. Several times he struck a match so that he could see where the floor boards were missing or broken ...

He heard the pattering of feet on the stairs and felt a cold, wet nose put into his hand. His little dog had come from the car to look for him and had found his way upstairs into the room. He stroked the little thing's soft ears and decided to wait a minute or two longer before leaving the gloomy old building.

Suddenly the little dog broke into a frenzy of terrified barking, the hair bristling along his back and his body trembled with rage and fear, then like a little bullet he hurled himself into the far corner of the room near the staircase, while his anxious master fumbled with a box of matches which kept dropping to the floor from his excited fingers. There seemed to be a struggle, swift and cruel in that dark corner of the room, then the barks of fear changed to a choking, sobbing effort to breathe, which grew less and less and then there was complete silence. When a match was at last struck there was nothing to be seen but the huddled body of his little fox terrier lying quite dead in the far corner of the room.' [43]

A long term resident of the Stone House had never seen a ghost here but he once stated that he believed that the ghost stories had been fabricated during the depression to encourage new business that would help to pay the bills. Ghost or no ghost, this is a gripping, ripping yarn.

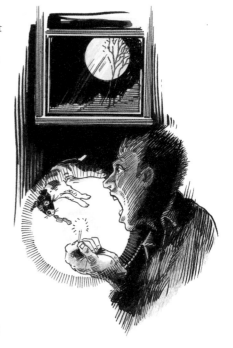

43 Further reading: *Short History of Latrobe* op. cit. p 46

The Bunyip of the Highlands

No book on folklore could fail to include a story
about the legendary Australian bunyip, *'a mythical
monster said to inhabit inland waterways'.*[44]
'Bunyip' is an Australian Aboriginal word for
some kind of water monster. The bunyip is usually
portrayed as a large, rapacious water creature
lurking in creeks, waterholes and lagoons ready
to leap out and devour any inattentive stockman,
shearer or overlander who may be camping near
its territory. Descriptions vary immensely, and
suggest it is as big as a bullock, has a maned neck
an emu's head and is furred or feathered. It is hard
to get a Tasmanian to admit that he has ever seen
a bunyip, but almost every bushman will know
someone that has.

Constable McPartland's son reported sighting a
bunyip in the Great Lake several times near Swan
Bay in 1868. The beast was purportedly *'four feet
long, darkish in colour, and moving through the
water, revealed a round head like a bulldog'.*

These sightings aroused considerable
interest and geological surveyor Charles
Gould was sent to investigate the sighting
in 1870. He enlisted the aid of local
shepherds employed by prominent graziers
Headlam, Kermode and Flexmore. All of
the shepherds had claimed to have also
seen the bunyip at different locations in
the lake.

They suggested that it was about
the size of a well-proportioned
sheep dog and moved at great
speed, approximately 30 mph [48 kph]
by using *'small flappers or wings'.* The
creature often sent water splashing up to
ten feet into the air. Sightings of bunyips at Lake Echo in the same year
by John Butler of *Shene* and the Rev HD Atkinson reinforced the Great
Lake experiences and descriptions.

After deliberating for a time, Gould came to the conclusion that the creatures
sighted must be fresh-water seals that had somehow swum up one of the rivers that
flowed out of the respective lakes.

44 *Readers Digest Word Power Dictionary*

However, long-term local shepherds and a reputable Melbourne solicitor Critchley Parker (who regularly visited Great Lake to fish) disagreed with Gould's findings.[45] There is a Bunyip Creek and Bunyip Falls at Mt Field National Park which implies that a bunyip must have been sighted here as well.

45 Further reading: *The Roof of Tasmania* (Tim Jetson) Pelion Press Launceston 1989 p 64; *Identities and History of Tasmania's High Country* (Ned Terry) Artemus 2005

Chapter 13 Animal antics

A rat attack

During WW2 the Hydro Electric Commission's Shannon Power Station played an important role in Tasmania's power supply for the war effort and consequently, it was regarded as vulnerable to an air attack. An army guard consisting of a corporal and six soldiers was posted close by to patrol the pipeline and to guard the power station. During this time, a rat short-circuited one of the transformers at the Shannon Power Station and caused the cut-out valve to engage and stop the flow of water to the turbines. This was a very noisy process and was accompanied by a series of electronic flashes. The guard on duty thought that the station was under attack so he called out *'They're here'*.

This warning caused consternation and all hell broke loose. The guard house erupted into life and panic-stricken soldiers and station workers came running to the station amid the strident sounds of air-attack alarms.

No lights were allowed as this would assist in an air attack, and the station was protected by barbed wire and a locked gate. In the confusion the key to the gate was lost in the thick snow and the gate had to be broken to gain entry. As soon as this occurred it was realised that it was a false alarm and that no attack was imminent. Thank heavens it wasn't a real raid or casualties would have been high. As it was, the only casualties were a dead rodent, a lost key and a broken gate; and perhaps an embarrassed station worker.[46]

46 *Waddamana, Shannon & Tarraleah Power Stations* HEC booklet p 47

Flossie flotsam

Most of the present generation have forgotten that it was common practice up to the 1950s to allow cattle with a grazing licence to graze in the streets to keep grass down in country towns. The town of Richmond had a cow called 'Flossie' that tended to graze alone, far from the madding herd. Flossie cultivated a bad habit of dropping moo-poo each day in front of the post office and it was rumoured that the natty patties were dropped expressly for the postmaster's garden. Flossie habitually aggravated councillors when they arrived for council meetings by licking their handsome cars or rubbing her backside on the gleaming duco bodies. She flaunted herself with some brazen grazin' outside the council chambers whenever councillors emerged for lunch.

One day Flossie's name appeared under the heading 'complaints' on the agenda for council business. The recalcitrant cow had finally overstepped the bounds of common decency. The complaint referred to the day that Flossie had cleverly opened the latch on a resident's gate, and after she entered, the gate had closed behind her. Now in solitary confinement, Flossie kept herself amused by demolishing a row of cabbages. In the process, she left behind her iconic piles of moo-poo that she usually reserved for the post office. When the owner's wife arrived home she was horrified at the devastation wrought by the fumigating, ruminating cow. The woman propped the gate open to usher the errant cow off the property and Flossie literally belched in the face of the enraged resident, which did not improve her temper. After the council discussed Flossie's misdemeanours, her fractious actions backfired on her (forgive the pun). At the next council meeting, councillors poo-poohed moo-poo in the town and all street grazing licences were withdrawn and Flossie's story (or should that be tail?) made headlines. No doubt Flossie was ostracised by her fellow grazers for doing the dirty on them.[47]

47 Further reading: *Memoirs of JJ (Joe) Cowburn* op. cit. pp 44-45

The running of the bulls

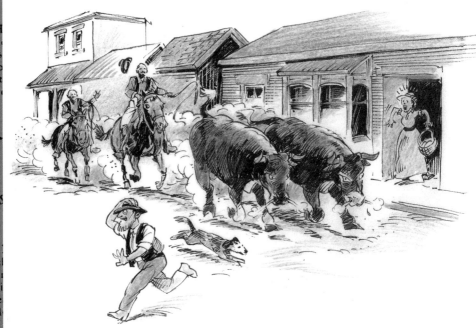

Horses were expensive, and in short supply in early Van Diemen's Land.
Therefore, oxen were frequently used as draught animals to pull drays or carts
through the towns. Cattle were often allowed to 'free range' in the bush as few
settlers could afford to build fences around their large farms, and they would
often become wild (the cattle that is). Sometimes beefy bovines were driven into
Launceston to be sold or slaughtered but there were no regulations governing
herding through the town in the 1840s. Consequently, whip-cracking drovers on
horseback, were frequently sighted, galloping at full speed through the streets in
pursuit of wild, stampeding bullocks. Long-term Launcestonians would listen
out for warning signals like the crack of a whip or the yelping of dogs before
instinctively scurrying into the nearest available doorway to escape the horns and
hooves of some infuriated charging bulls. Several accidents (some of them fatal)
occurred because of this reckless practice. Some might call this a horny dilemma.[48]

48 Further reading: *Flotsam & Jetsam* op. cit. p 66

Dawg-gone

A farmer drove his car into the Deloraine branch of Websters to get some farm supplies. When he lifted the lid of the boot, a half-starved red kelpie farm dog leapt out. The bedraggled dog trotted over to a wall of the warehouse upon which he urgently relieved himself for a considerable time. While he was doing so, the farmer scratched his head.

'*Crikey,*' he said in amazement, '*So that's where he was, I have been looking for him for a week.*'[49]

How do you tame a wild horse?

Steve Hay, of Southport made the following comments when talking about his grandfather John Hay II :-

'He cut a large amount of timber, sending it all over the world - to China, India, England and the U.S., where some of the wooden houses in San Francisco were built from Hastings timber. Women also collected the leaves from the fallen trees, which my grandfather distilled, sending the oil overseas in drums. ... They would bring the logs to the mill on trolleys. They had a stallion in the team which was wild and savage. He would lay his ears back, open his mouth and charge. Everyone was afraid of him.

One day they were bringing a load into the mill on the trolleys; the stallion went through the (timber clad) road. He was jammed and could not move. His backside was up and his head down under the tramroad. My father [Robert Hay] pulled his pocketknife out and castrated him while he was jammed. Mr. [Bill] Curran said that quietened him and he turned out to be the best leader of all the horses of any of the horse teams at the Hastings Mill.'[50]

49 Advised by Dale Smith January 2009
50 Further reading: *Richard Bennett's Huon Valley* Geeveston 1988 p 94

McRorie's pigs

As land at Cambridge is relatively flat, many people were surprised at the winding nature of the now disused Bellerive to Sorell railway. The answer lies in unrequited love (as true love never runs smooth). When the Tasmanian Government Railways planned to build the railway in 1890/1 it employed surveyor Patterson to survey the track route. Patterson set up his camp just inside farmer McRorie's property at Cambridge during his survey of the line. All was going well until Patterson was distracted by McRorie's attractive daughter. When he bravely began to court the girl her father saw red and he ordered the ardent suitor off his land. Patterson retaliated by telling the over-protective farmer that he was going to establish the Cambridge station on McRorie's land and that it now belonged to the railway and that was that! McRorie was enraged by this flagrant abuse of power and he starved his pigs for a few days and while Patterson was away he sent them into Patterson's camp. The pigs created havoc when they ate most of Patterson's stores. This action was repeated several times and Patterson decided to take decisive action.

He inserted detonators into his potatoes and scattered them around his campsite. When the pigs came next day three quarters of them were killed and the remainder ruefully limped home, some of them with their jaws blown away. Not content with this 'payback', Patterson sought additional revenge by routing the railway across McRorie's land as many times as he could to take the maximum amount of land off McRorie. This accounts for the winding route of the railway which is not as apparent today because the railway closed in 1926 (and the lines have been since removed). I doubt if after this coup de grace that Patterson ever succeeded in marrying McRorie's daughter. Pigs might fly.[51]

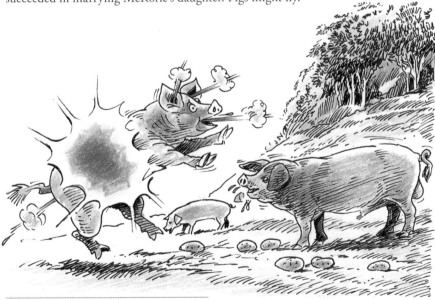

51 Further reading: *The Bellerive to Sorell Railway Revisited* (J Houghton) Bellerive Historical
 Society 2007 p 15

Capt. James Kelly

Chapter 14 Fish & ships

Capt. Kelly - the hero

James Kelly the well known and respected
sea captain, whaler, sealer, harbour master and river pilot
of the Derwent has become an icon of Tasmanian history. Today he is mainly
remembered in the naming of Kelly's Steps in Salamanca Place. However, his main
claim to early fame was his circumnavigation of Van Diemen's Land in 1815-16
in a whaling boat. History books are filled with Kelly's deeds but there is a darker
side to him that is seldom told. The author made a visit to the Otago area of New
Zealand in 1994 where the tour guide explained a dramatic event that occurred
there in 1817. A group of Maoris attacked Kelly and his crew and in the melee three
of Kelly's crew were killed. The *Hobart Town Gazette* of 18th March, 1818 records
Kelly's version of the story:-

...The *'Sophia'*, Mr. James Kelly, Master, sailed from Hobart Town on 12th
November 1817 on a sealing voyage, and anchored at Port Daniel, on
the South East side of the Southern part of New Zealand, on the 11th of
December (a place only known to Europeans within the last 7 years). ... On
reaching the house of the chief, Mr. Kelly was saluted by a Lascar (Indian),
who told him he had been left there by the brig *'Matilda'* (Capt. Fowler). ... In
an instant a horrid shout was made by the natives; when Kelly, John Griffiths
and Veto Viole were thrown down by the mob: Tucker, Dutton and Wallon
were also seized but got away and ran for the boat where they found the man
Robinson, who had charge, reeling on the beach from a wound in the head.
... In the meantime Kelly was engaged in a dreadful combat with the
natives, and luckily having about him a bill-hook, he miraculously effected
his escape (being only speared through the left hand), after wounding his
principal opponent on the head. ... Tucker was still on the beach. Dutton,
Wallon and Robinson, were in the boat backing her out of the surf. Kelly
made the boat, and was dragged by her through the surf, calling on Tucker
to follow; who however, would not attempt to do so till too late, a number
of savages immediately rushing down on the beach armed with spears and
hatchets. Tucker kept calling to them not to hurt 'Wioree', but regardless of
his entreaties, he was speared through the right thigh by the man who Kelly
had wounded ... and was immediately knocked down in the surf where he was
cut limb from limb and carried away by the savages having only had time to
utter *'Kelly, for God's Sake don't leave me.'* Kelly and the 3 men now returned
to the vessel and found on board a number of natives of the village. These,
however, Kelly humanely sent on shore, considering the principle of revenge
in such cases unjustifiable, and, without further intercourse, in four days
proceeded on his voyage.

Capt. Kelly - the villain

The New Zealand version of the previous article is remarkably different and reveals a vicious side to Kelly's nature that was not mentioned in his own accounts of his 'heroic' deeds. A tour guide stated in 1994 that Kelly's crew massacred a large number of Maoris as an act of retribution for the loss of three of his men in 1817. Kelly's men crept into the village of a neighbouring tribe who had nothing to do with the earlier attack. In the dead of night the crew slaughtered about 70 sleeping villagers with sealing knives. Not content with this grisly and gross over-reaction, Kelly's crew burnt their huts and destroyed their canoes to prevent any survivors from pursuing the murderers. Kelly then moved away from the scene of the massacre and calmly traded with other Maori tribes who were at that time unaware of the atrocities. However, from that time onwards, Kelly was a marked man and several Maori tribes were perpetually on the lookout for him should he ever return. An article in a travel guide gives the following version of Kelly's visit:

'Capt. James Kelly, a sealer notorious for his barbarity, was attacked while he sought to trade iron for potatoes. One of his party [W. Tucker] had been recognised as a person who had traded in preserved heads [valued because of the distinctive Maori tattoos]. Three of the party were lost including the luckless trader, but Kelly and his men made it back to their brig *'Sophia'* where they found a [another] group of Maoris in all innocence trying to trade. These Kelly and his crew attacked with sealing knives, and before the savage scenario was played out, the ruthless Kelly and his men killed some seventy Maoris. [They] Smashed a number of canoes, and reduced to ashes the kainga [Maori village] they contemptuously designated the 'City of Otago'. A measure of Kelly's single-mindedness shows that the loss of his men did not deter him from the purpose of his trip. He collected 3,000 sealskins before he returned to Hobart.'[52]

The conflicting nature of the New Zealand and Hobart reports highlights the need for healthy scepticism when reading newspaper reports of events, especially those relating to activities of the past. In this instance, our Tasmanian history of the Kelly incident is not complete without taking into consideration the Maori version of the resultant mass murders that took place in Otago (even though they sound grossly exaggerated).

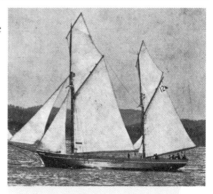

Ketch *Huon Pine*

52 *Mobil New Zealand Travel Guide* (South Island) (D. & J. Pope) p 102

Capt. Kelly – the victim

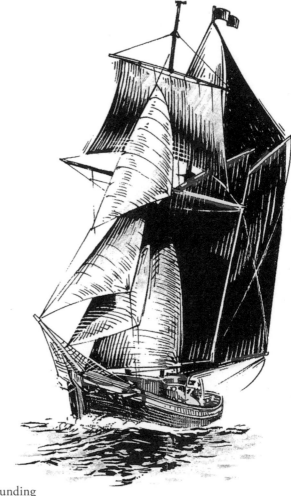

Capt. James Kelly died in
1859 aged 66 years. His
tomb in St David's Park
Hobart records a sad saga
of unfortunate events surrounding
the deaths of his family. One of them was James Bruni Kelly aged twenty one
years, *'eldest son of James and Elizabeth Kelly who was killed by a blow from a whale
on 10 August 1841'*. Another memorial records the death of third son Thomas *'who
was drowned by the upsetting of a boat in the river Derwent on 18 October 1842
aged sixteen years and eight months…'*. Five more of Kelly's children were recorded
on the tombstone, viz: John aged one day, Elizabeth Jane aged fourteen years six
months, Harriet aged two days, Eliza aged one month and eleven days and George
five months and fifteen days. Seven of the Kelly children died before their parents.
Perhaps the most heartbreaking event was when Kelly's wife Elizabeth died
2 July 1831 aged thirty five years predeceasing her husband by twenty eight years.[53]

53 Further reading: *In Old Days and These* ('The Captain') Monotone Art Printers Hobart 1930

The ubiquitous brig *Lady Nelson*

The tiny brig *Lady Nelson* (60 tons) is the most remarkable vessel in Australian history. She was built at Deptford, England in 1799 using the sliding keel system (the fore-runner of the modern centre-board). This system was evolved in 1783 by Capt. John Shanck RN. The system proved to be so successful that sliding keels became standard for most small ships. After trials, the *Lady Nelson* was commissioned in January 1800 for survey work on the Australian coast as her draught was only 2 metres. She was armed with two brass carriage guns and carried a crew of 15 and put under the command of Lieutenant James Grant.

She sailed in a convoy from Portsmouth 16 March 1800 but when she was outsailed in windy weather she suffered the indignity of being towed for part of the way. She reached Australia on 2 December 1800 and sailed along the south coast passing through Bass Strait to become the first vessel to do so from west to east. The ship then embarked on a series of surveys until Grant returned to England towards the end of 1801. She had no less than three commanders within two years including Lieutenant John Murray, Lieutenant George Curtoys and Lieutenant James Symons. From 1803 the brig made a huge impact on the settlement of Van Diemen's Land as she brought settlers to Risdon (September 1803), Hobart Town (February 1804) and Port Dalrymple (November 1804). She also brought NSW governor Lachlan Macquarie to Van Diemen's Land in 1811. She did more work on coastal surveys around Australia than any other vessel. She also visited New Zealand and the South Pacific. In 1824 as tender for HMS *Tamar* she helped form settlements on the north coast of Australia and Melville Island. At this time she came to grief when visiting the Dutch East Indies for a cargo of buffalo meat. Unfortunately she was boarded by pirates near the island of Baba and was eventually scuttled there.[54]

[54] *Historical Brevities of Tasmania* (Moore Robinson) Government Printer Hobart 1937 pp 65-68

Buried treasure and forlorn *Hope*

The 231 ton Venice-built barque *Hope* arrived in Storm Bay near dusk on 28 April 1827 after sailing from Sydney with general cargo and several passengers under the command of Capt. Cunningham. The pilot Masefield went on board and the master went below leaving the vessel under the command of chief officer Henry Park. At 4am Park also went below leaving the second officer Downs at the helm. Shortly afterwards Downs reported that the ship was ashore on a low sandy beach now known as Hope Beach. In *'the terror and confusion'* that followed the master ranted at the pilot who looked on with mute dismay. The water began to fill the hold and all efforts to tow the ship off the beach failed. One of the towing whaleboats overturned and the crew struggled ashore without drowning.

The passengers and crew were taken off the ship and some were taken to Hobart by whaleboat and the remainder were forced to camp on the beach. A subsequent inquiry dismissed accusations that the pilot was intoxicated and it was found that he did not see the low-lying coastline in the turbulent conditions.

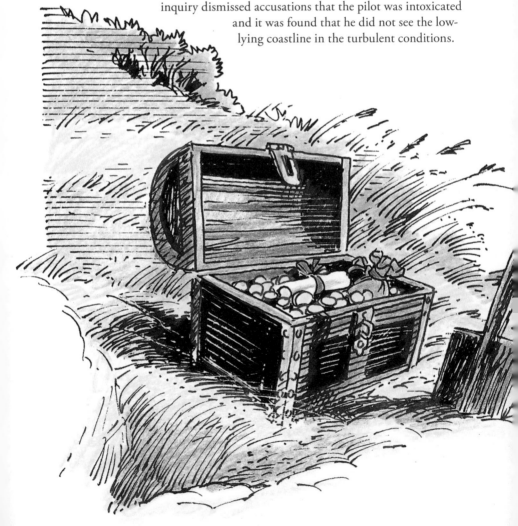

The wreck broke up in a gale on 4 May 1827 but was nevertheless sold to Capt. John Laughton. Ironically, Laughton was drowned the very next day off Maria Island leaving a wife and three children.

It was rumoured that on board the ship at the time of the wreck was a treasure chest that contained the garrison's payroll in silver coin. The chest was under the control of Ensign Buckley and guarded by two soldiers, but it disappeared. It was suspected that it was stolen by two crew members and hidden by two guards charged with bringing it to Hobart Town. If that was the case, the men had no chance of retrieving the treasure as the men concerned were transferred to India where one of them died.

However, the survivor told the story to an Irish farmer called McKinnon and convinced him that the treasure was still to be found and he drew him a map to disclose the exact location. McKinnon engaged Donald McKay of the *Mary Kay* to land him on Bruny Island with his gear. Local resident Harry Denne saw McKinnon struggling to land his gear and he ran to help him. McKinnon resisted all efforts to explain what he was doing and this aroused the curiosity of locals. McKinnon prospected for several weeks and then mysteriously disappeared.

He returned eighteen months later, reputedly with a fresh map, after returning to Ireland to get more specific instructions from the soldier. This time he arranged with Capt. Bill Whisbey to convey him to Bligh Point one mile to the south of Kellys Point on Bruny Island in his ketch *Anne Allen*. After another fruitless search and running out of money, McKinnon gave up the hunt and returned to Hobart Town where he became a labourer. I wonder if the soldier had told the gullible McKinnon a tall story to have some fun with him. Nevertheless, many other people heard the rumour and began to fruitlessly rummage through the sand on Hope Beach at South Arm and several beaches on neighbouring Bruny Island in an endeavour to find the missing treasure.[55]

55 Further reading: *Wrecks in Tasmanian Waters* op. cit. pp 14-17

The woman who posed as a male sailor

Much ado has been made about the first white woman to step ashore in Van Diemen's Land. Descendants of Martha Hayes claim that she was the first woman to be carried ashore by Bowen's crew when Risdon was settled in 1803. Martha was the mistress of Lieutenant John Bowen, so it is possible that Bowen allowed her the honour of being the first woman to leave his ship. Nevertheless, Martha's story is debatable, as all the women aboard were carried ashore by soldiers or sailors and it would have been a matter of luck as to which fair maiden was the first to be deposited ashore.

However, the various claimants would all be appalled to know that Martha had been preceded eleven years earlier by a French woman by the name Marie Louise Victoire Girardin (1754-94). Ms. Girardin arrived with the d'Entrecasteaux expedition in 1792/3.

Marie had been widowed in the early days of the French Revolution and during the expedition she dressed as a male and posed as a sailor named 'Louis'. She was petite and plain, and youthful in appearance, so she managed to get away with her deception. D'Entrecasteaux's deputy Huon de Kermadec assigned her as a steward aboard the flag ship *Recherche* (almost certainly with d'Entrecasteaux's knowledge of her true gender). As a steward Girardin was able to escape the medical examinations that sailors were subjected to and she was allotted a small cabin for privacy. Although many of the crew suspected that Girardin was 'a woman disguised', she maintained her assumed identity with great tenacity. She went to extraordinary lengths to prove her 'masculinity' and she even challenged an impertinent junior pilot to a duel, sustaining a gash on the arm for her impetuosity. 'Louis' was lucky to have escaped exposure in 1793 when a party of sailors met some Aborigines in the lower Channel. The natives were very curious about the sex of some young beardless sailors and they were examined intimately to ascertain their gender.

From a crewman's journals it can be deduced that she formed a relationship with Merite, a young ensign aboard *Recherche*. In a romantic twist of fate, the two lovers died within a day of each other in December 1794 when the expedition was ravaged with scurvy and dysentery in the Dutch East Indies on the homeward voyage. The enormous dangers of travelling on board ships in tropical climates, was highlighted when 40% of the French expedition members died near Java within a few months. It was at this time that Girardin was 'positively discovered to be a woman', as had long been suspected. It is interesting to note that Jaques-Laurent Boucher (c1771-94), a young gunner of the *Esperance* died of consumption during the Van Diemen's Land visits. He was probably the first European to be buried in Van Diemen's Land, but there is no record of his grave site.[56]

56 Further reading: *Voyage to Australia & the Pacific* (E & M Duyker) Melbourne University Press Carlton South, Victoria 2001 pp xxv, xxxv; *Citizen Labillardiere* (Edward Duyker) The Miegunyah Press Carlton South, Victoria 2003 pp 150, 198, 292

The 'Floating Brothel'

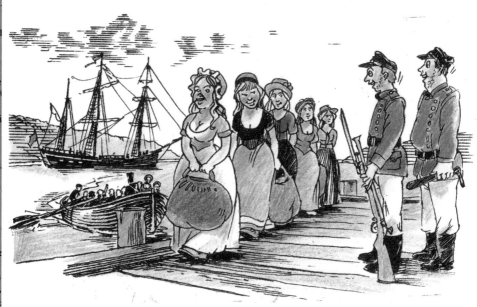

One of the juiciest stories in our maritime history is the 'love boat' voyage in 1790 of the 401 ton sailing ship *Lady Juliana* (Capt. Aitken) from the UK to Sydney. This story is relevant to Tasmania as many of her convict passengers later settled here.

The saga began in London on 31 October 1788 when Lord Sydney told the Treasury that he wished to send at least 200 convict women to NSW. This decision was made to partially alleviate the health risks associated with gross overcrowding in British gaols. This action would also help to redress the large imbalance of males to females in the new colony of NSW. After some interminably long delays, *Lady Juliana* began loading female prisoners of child-bearing age in mid March 1789 and she left Plymouth on 29 July 1789. John Nicol, the ship's steward aboard the *Lady Juliana* made some revealing comments in his autobiography of 1822:

'We lay six months in the river [Thames] before we sailed; during which time, all the jails in England were emptied [of women] to complete the cargo for *Lady Julian*. [sic]… When we sailed there were on board 246 [226] female convicts. There was not a great many very bad characters; the greater number were for petty crimes, and a great proportion for only being disorderly, that is, street walkers; the colony at the time being in great want of women.'

John Nicol recalls: *'when we were fairly out to sea, every man on board took a wife from among the convicts, they nothing loath.'*

This comment epitomises the immoral custom of British officers aboard convict transports to select a mistress almost immediately from among young females on board. The women rarely demurred as it was a huge advantage to have a senior officer as a protector. Obviously, these liaisons helped to pass the time pleasurably on those monotonous, interminably long sea voyages. Nicol stressed that the *Lady Juliana* women (who were mostly teenagers or young women of child-bearing age) willingly entered into intimate relationships with sailors and were not coerced or raped. Nicol admitted to spending a week courting the nineteen years old Sarah Whitlam before she finally yielded: *'I fixed my fancy on her from the moment I knocked the rivet out of her irons upon the anvil.'* Others, who were not committed to one man, chose to sell their favours. Some women chose to work rather than play and they earned money making shirts out of linen owned by Capt. Aitken. He made a tidy profit when he sold the shirts in Sydney.

The *Lady Juliana* called into many ports en route (e.g. the ship remained for forty-five days at Rio de Janeiro and nineteen days at Cape Town). These long breaks enabled many convicts to 'sell their favours' to local residents or visiting officers from other ships in port. The frequent stops enabled food and water supplies to be frequently refreshed and minimise scurvy, ill health and deaths. The vessel was kept clean and fumigated, and the women were given free access to the deck to get some fresh air. Consequently, only five convicts died en route and the women arrived *'healthier and happier than they had ever been before'*. This was in stark contrast with the rest of the Second Fleet, which was stalked by high incidences of sickness and loss of life; largely due to mistreatment, malnutrition and poor hygiene.

The *Lady Juliana* arrived at Port Jackson on 6 June 1790, taking a mammoth 309 days for the voyage. This caused a sensation in London because the average trip usually took from four to six months. As a consequence, The *Lady Juliana* was later nicknamed *The Floating Brothel*, or HMS *Bordello*. The *Lady Juliana* previously sailed to NSW with the First Fleet in 1787-8 but she is usually best remembered for her infamous second voyage. She was the second ship to arrive in Sydney after the First Fleet.[57]

Whale tales (or wails about whales)

Whaling in the 1800s was the most dangerous occupation imaginable. It was also the smelliest, greasiest, messiest, most exhausting employment of all time. The working conditions were atrocious. Whalers had to contend with long hours, hard work, basic food, inadequate shelter and rough seas. Long, hard chases after whales often proved fruitless. In a bad season a whaler would be lucky to get paid (although he was fed and housed).

57 Further reading: *The Second Fleet* (Michael Flynn) Library of Australian History Sydney 2001 pp 16-20

Why then would men be attracted to such a profession? Well, whaling was the most exciting activity a young man could pursue in the nineteenth century. There was plenty of adventure, thrills and adrenaline pumping moments and action aplenty. Best of all, the pay was excellent in a good season.

A number of horrifying things could happen when a boat was being dragged by a wounded whale and quick action was required to prevent a calamity. Consequently, the crew was trained to follow orders instantly and without question because any miscalculation could mean death for one or all on board. Newspapers and diary notes of the early 1800s in Hobart Town frequently reported some gripping, (often grisly) tales of lively encounters with whales. Here are five typical examples:

1. 'At 7 [am], Capt. Merrick went on board the *Aurora* and at 11, seeing a whale, he went after it with only one [whaling] boat. He struck her and when she rose again he put another iron into her; she then turned and struck the boat, and stove it, that they were obliged to cut the ropes which held the whale. The boat filled so fast that they were obliged to hang on to their oars. In that dreadful state they continued for 5 hours. One man was knocked over when the whale struck the boat and went down. At 1 pm another of the men died in the boat and at 2 another died. Capt. Merrick and 2 men continued in the boat with the water up to their waists, till a boat from the *Elizabeth* came to their assistance, and when they arrived they were very near going down. They were 5 hours in the water, expecting every moment that the boat would part with them, and had not the boat fortunately arrived every soul must have perished as they were so deep in the water and they began to be stiff with the cold water.' [58]

2. '...One man was dragged out of the boat by a whale, the line having entangled his legs. He was dragged to the bottom; his companions watched with intense anxiety the reappearance of the whale; when they again saw the man the line had fastened around his thigh and had cut through the trousers to the bone. They now cut the line, when the fish dashed through the water with incredible celerity and the man was never after seen.'[59]

3. A crewman employed by whaler William Maule in 1829 managed to get his foot entangled in a harpoon line when whaling off Kangaroo Bluff, Bellerive. He was pulled out of the boat and down beneath the water as the whale dived. He rose to the surface and swam around until he was picked up by one of the boats. It was then found that his leg had been severed above the ankle. As an aside, a baby whale was taken from the captured whale. This was exhibited in a public space to raise funds for the injured whaler.[60]

58 *Rev. Knopwood's Diary* 31 May 1807
59 Further reading: *Friendly Mission* op. cit. p 710
60 Further reading: *Wrecks in Tasmanian Waters* (Harry O'May) p 19

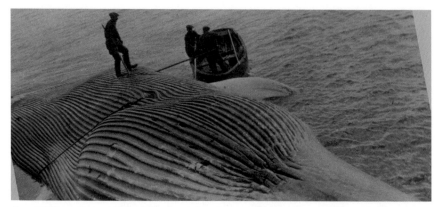

4. William Legar of the Whaling ship *Prince Regent* (Capt. William Anderson) was killed off Cape Pillar on 20 July 1820 when struck by a whale and knocked out of the boat.[61]

5. One day in the 1830s a whaleboat from Capt. Bayley's *Fortitude* struck a whale which took off at great speed, towing the boat away from the ship. The ship soon lost sight of the boat and when night fell, fires were lit on the deck to guide the missing boat to safety. At daybreak there was still no sign of the boat, and one enterprising sailor climbed a mast and sighted some sea birds acting strangely. The ship headed in that direction and found the boat bottom-up with Capt. Bayley clinging to her, even though he was unconscious. It was found that Bayley had removed the plug of the boat and inserted his forefinger which became swollen and kept him above water and 'attached' to the boat. The garboard strake of the boat had to be split to release him. The rest of his crew had perished.[62]

The flail of the tail of the whale

The following rollicking news article gives us further confirmation of the dangers of whaling:

> 'A few days ago, while one of the boats belonging to the *Seringapatam* whaler was fast to a whale, the furious animal struck the boat with such violence as to nearly dash it to pieces; but what is more lamentable, at the same moment, one of the unfortunate boatmen, who were then all in the water, received a severe concussion on the back of the head from the fluke [the lobe of a whale's tail] of the animal, that it occasioned the poor fellow's death instantaneously; and another of his companions had his shoulder dislocated by the same whale; which they however succeeded in taking.'[63]

61 *HTG* 22 July 1820
62 Further reading: *Wrecks in Tasmanian Waters* op. cit. p 42
63 *Hobart Town Gazette, and Van Diemen's Land Advertiser* Saturday 6 July 1822 p 2

Whalers' concubines

George Augustus Robinson (the conciliator of Aborigines) recorded in his journals the inclination of whalers on Bruny Island to entice Aboriginal females into a form of prostitution.

'19 September 1829 - The Aborigine Woorrady returned to the establishment [Aboriginal mission station, Bruny Island] …. He said that the three females Dray, Trugananna [Trugernanna/Truganini], and Pagerly had gone to Bull Bay [whaling station].'[64]

An Aboriginal informant named Robert advised Robinson that Aboriginal women slept with white men [whalers] many evenings and *that they [the whalers] gave them plenty of tea, sugar, meat and tobacco*. After receiving this information, Robinson in his quaint, imperious fashion recorded the following notes in his journal:

'Walked to the whalers in company with Woorrady; saw a great number of whales carcases. Upon our arrival there Woorrady showed me their place of dwelling - the women it appears on seeing us had absconded out of sight. Saw one of [James] Kelly's overseers; told him my feelings on the subject and that I should represent the circumstances to the Governor [Sir George Arthur]. Here is a large establishment consisting of three firms: Messrs [James] Kelly & Lucas, Messrs [William] Young and [Bernard] Walford and Mr. [William] Maycock. The number of men collectively are from eighty to ninety in number; there are two schooners, two sloops and a large number of [whale] boats.

It appears that they have been very successful this season [1829]. The conduct of these parties in harbouring a plurality of Aboriginal females, who were arriving fast to a state of comparative civilisation, making them subservient to their own carnal appetites, is too aggravated to be passed over with impunity. Letters sent to each of the firms positively prohibiting any intercourse with the natives whatever, therefore they cannot plead ignorance of the subject.'[65]

John Freake commented on the situation on 27 November 1829:

'I never knew any of them [female Aborigines] to have venereal disease … They used to go of their own accord to the whalers and cohabited with them. Mr. Robinson went to bring them back two or three times, but they would not return with him. I heard they ran away and hid themselves.'[66]

64 Further reading: *Friendly Mission* op. cit. p 74
65 Ibid p 72
66 Ibid p 105 n 52

Sealers and sheilas

Before the political-correctness lobby starts to lambast me for denigrating Aboriginal women by calling them 'sheilas', I protest my innocence and state that I have only used the term in fun because the words 'sealers' and 'sheilas' happen to rhyme. Much has been said about the tendency of sealers to have several Aboriginal 'wives', almost as trophies. The more wives they have, the higher the status of the sealer. Capt. James Kelly in his narration of his circumnavigation of Van Diemen's Land in 1815-16 stated:

> 'Briggs had been employed as a sealer in the islands in Bass's Straits for many years previously, and had acquired the native language of the north-east coast of Van Diemen's Land fluently, in consequence of his often gone over from the island to Cape Portland to barter for kangaroo skins with the natives, as also to purchase the young grown-up native females to keep them as their wives, whom they employed, as they were wonderfully dextrous in hunting kangaroo and catching seals. The custom of the sealers in the straits was that every man should have from two to five of these native women for their own use and benefit, and to select any of them that they thought proper to cohabit with as their wives, and a large number of children had been born as a consequence of these unions – a fine, active, hardy race. The males were good boatmen, kangaroo hunters and sealers; the women extraordinarily clever assistants to them. They were generally very good looking, and of a light copper colour.'[67]

Kelly also said:

> 'They [the sealers] also seduce the native women and have children by them and instances have occurred of their Purchasing them of their Husbands in exchange for Carcases of the seals after they had taken the skins off. They likewise sometimes carry them off by Force and employing them in Hunting Kangaroos for their skins and also in killing Seals, at which the women are very expert.'[68]

George Augustus Robinson interviewed two sealers and told them that numerous complaints had been received by the government regarding the conduct of sealers towards the Aborigines of the colony. Robinson added:

67 Further reading: *James Kelly's Narrative of his boat voyage round Van Diemen's Land in 1815* (James Calder) 1881 pp 26-27
68 Further reading: *HRA III III* pp 461-462

'[I] informed them that the government was aware of the way that they procure their women, how they rushed upon them at their fires and shot the men. They assured me that they had not so obtained their women.'[69]

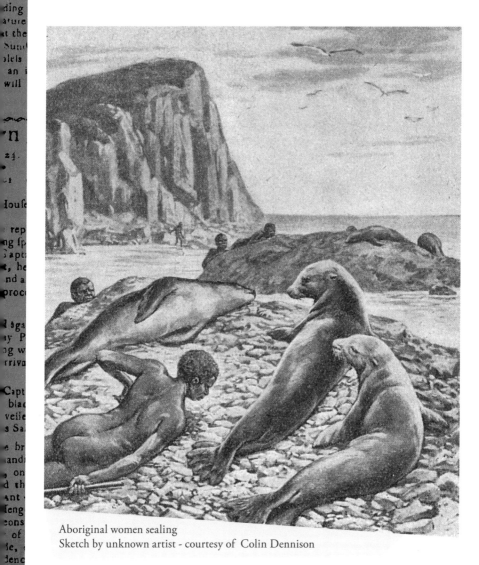

Aboriginal women sealing
Sketch by unknown artist - courtesy of Colin Dennison

69 Further reading: *Friendly Mission* op. cit. p 180

The 'dirty dozen' sent buzzing

Jounalist TG Ford who wrote under the assumed name of *The Captain* in the 1930s, told the following gripping story that reveals that Aboriginal women were not always fully submissive to their sealer masters:

'Whalers, sealers and convicts became sea rats and sea wolves by turn. These escaped convicts were difficult to trap. The only god they knew was the god belly, and their life of daring was lived to fill their god with rum and to satisfy their sensuality by licentious conduct with native women. They descended upon the shores of Tasmania and seized the young girls of the natives. Such women suffered great cruelty at the hands of the sealers. They worked them like slaves and thrashed them when the work of skinning seals or cleaning mutton birds was done. But the women had their day sometimes. One rare case of triumph is recorded when the wit of a woman out-distanced for ever the bestial desires of more than a dozen sealing men. The incident is related in the *Hobart Town Gazette*, 1824. A sealer named Duncan Bell was successful in stealing a native Tasmanian girl, with whom he cohabitated for a couple of years. He then desired to have more women for himself and his mates. Bell asked his woman (who had a child to him) to decoy some of the young women of her tribe to the beach. The act was agreed to. The sealers set sail from the islands with this woman and her child for Tasmania. They landed, and she went with her child into the bush, remaining away for three days. On returning she said that she had decoyed the women to the vicinity of the beach where the sealers were camped, and that next day they would have their gins.

That night she secured the only musket the sealers had. In the morning she told Bell to remain in the boat, while she led the men to the women. Once well into the bush she asked the men to wait. She had not long departed from them when her infuriated tribe, under her directions, rushed on to the sailors, waiting like so many tarquins, and slaughtered them. While the massacre was going on, she hurried back to the seashore and cried out to Bell to save himself, and then, turning inshore, she hurried back to her tribe. Bell took the woman's warning and made good his escape, but he never saw again the mother of his child, or the child of his rapine.'

Although this is a magnificent yarn, I really worry about the lack of details in this story. What was the name of the Aboriginal heroine? What were the names of the sealers who were murdered? Where did the massacre take place? When did it occur? What happened to the heroine and her child? Experience has taught me over the years to be quite cynical about rollicking yarns which contain very few details to enable the story to be verified.

Waubadebar - the heroine

One of the enduring legends of Bicheno is the fascinating story of Waubadebar, a female Aborigine who was abducted by whalers/sealers when she was just fifteen years old and was forced to live with one of them. Waubadebar, like most native women, was an excellent swimmer and was adept at killing seals. She became a legendary figure on the east coast and there are several variations about her life. The legend goes something like this: Waubadebar was the wife of a sealer/whaler who got into trouble in rough weather when a whale boat overturned. Her husband suffered a broken arm and was only semiconscious when Waubadebar rescued him and brought him to safety despite dangerous heavy surf. Then she returned to rescue the other man who was clinging to a rock. She then nursed both of them back to health. This event occurred many years before there was a permanent settlement here. Waubadebar is remembered by a simple headstone erected in her honour on the reserve enclosed by a fence.[70]

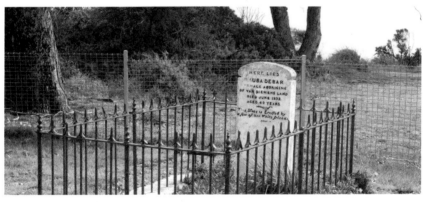

A diary kept by an old settler states that he subscribed to the monument erection fund on 17 April 1855. Bicheno was a whaling settlement in the 1820-30s and was probably home to a sealing industry before that. The Bicheno Harbour was originally known as Waub's Harbour, presumably named in her honour.[71] The inscription on the headstone reads:

> *'HERE LIES WAUBADEBAR,*
> *a female Aborigine of Van Diemen's Land,*
> *died June 1832 aged 40 years.*
> *This stone is erected by a few of her white friends'*

70 Further reading: *Glamorgan* (Davenport & Amos) Glamorgan Municipal Council pp 109-110
71 *Ibid.* p 109; *Friendly Mission* op. cit. p 141

Pedra Branca

Pedra Branca is a rock island sited off Tasmania's South East Cape. It is noted for its isolation, wild weather, huge surges and enormous waves. Abel Tasman named this 2.5 ha rock island on 29 November 1642 as he thought it looked similar to a rock of that name located in the South China Sea. The name means 'White Rock' in Portuguese because of bird droppings. Pedra Branca and the Houtman Abrolhos Islands in Western Australia are the only two Australian place names with a Portuguese origin.

Mountainous seventeen metre waves were ridden here for the first time on 11 October 2008 by a group of international surfers who were towed out by jet-skis. The rock has been the site of at least two disasters in recent years. A new steel Japanese fishing vessel of 254 tons *Nisshin Maru No.8*, (Capt. Nakayama) en route to Hobart for mechanical inspection struck Pedra Branca at 2.30 am on 7 February 1973. She ran up onto a ledge and then rolled and sank in deep water within minutes. The sole survivor of the crew of twenty two was engineer Yoshiichi Meguro who clambered onto the rocks to escape drowning. He was fortuitously rescued the next day by the fishing vessel *Walrus*.

In another incident, New Zealander Hamish Alan Saunders was washed off the rock by a freak wave on 15 April 2003 while undertaking research into the island's birds, seals and endemic skinks [lizards]. He was aged 26 years at the date of his death. Three of his colleagues on the rock were fortunate to survive the same fate.[72]

72 *The Mercury* 23 October 2008 pp 1-2 and 25 October 2008 p7;
http://www.courtlists.tas.gov.au/magistrate/decisions/coroners/has.htm

Raunchy Hobart in the 1830s

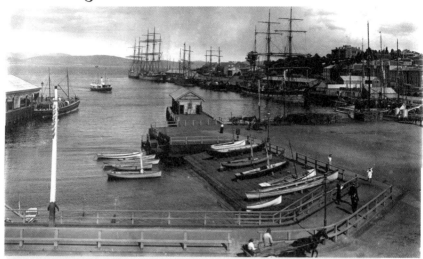

Watermens Dock c1850s
Photo courtesy The Copicentre Phillip Oakford Collection

Edward Markham an Englishman who visited Hobart Town in the 1830s had the following remarks about the town.

'From time immemorial whales have come up the Derwent to calve, and one was even recorded as far up the river as New Norfolk. ... Ships from all over the world used to come whaling into these southern waters, and ship-loads of peculiar characters came with them to Hobart, where money was scarce and rum was very plentiful. Spaniards with black hair and rings in their ears, Americans, hard drinking and tattoed in the most unlikely places, Portuguese and Frenchmen, they all came and all wanted the same thing. ... Strong drink had such a hold on the populace in those days that we are told that the whole community was drunk together for weeks at a time. ... Debauchery, disease, crime and death were brought about by the drinking habits of the people. One half of the deaths in the colony were caused by it, and it was always dangerous to walk through the streets, even in the day-time. ... When a shipload of 200 female convicts arrived from Sydney and landed among the preponderantly masculine population in Hobart, there was an almost uncontrolled rush for wives. The strongest men carried off the fairest brides and those who were weak had to be content with what was left. 'Yet,' as the historian West piously tells us, 'such is the power of social affections, that several of these unions yielded all the ordinary consolations of domestic life.'[73]

73 *Edward Markham's Van Diemen's Land Journal 1833* (KR von Stieglitz) Telegraph Printery Launceston 1952

Storm Bay and the mother of all storms

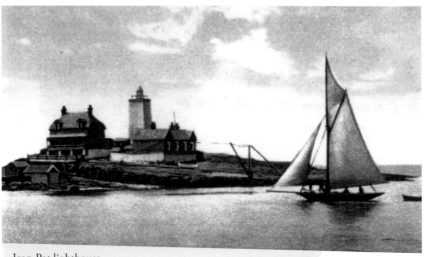

Iron Pot lighthouse
Photo courtesy of Colin Dennison

In 1895 a destructive storm buffeted the south-east of Tasmania. The storm grew quickly in intensity after dusk and the force of the winds driving across Storm Bay forced great tidal surges into the narrow mouth of the River Derwent. The Iron Pot bore the brunt of the storm and the lighthouse keepers were in grave danger of being swept off the rock to almost certain death. The keepers had no chance of escape in the dark and they decided wisely that the safest place for them was in the main house. The three families on the island bravely ran to the large house and the ferocity of the wind dashed their lanterns from their hands and they had to grope around in the darkness.

The move was just in time as a surge of water poured into the other buildings on the island with such force that it was feared that the sturdy structures would be washed away. Five of the seven full water tanks and timber buildings were swept away and huge boulders were displaced by the storm. Fortunately for the large house a sturdy stone oil store house broke the main force of the waves and saved the house. To their credit, the light-keepers kept watch in the lighthouse during the height of the storm, which was just as well, because the outward bound SS *Oonah* could not make headway against the terrifying winds and it sought shelter under the lea of Betsey Island.

When the shell-shocked keepers inspected the island next day they found devastation everywhere. As a testament to the ferocity of the storm, some pieces of kelp were left hanging from the uppermost rails of the lighthouse some 25 metres above sea level.[74]

74 *Iron Pot Lighthouse* (Marilyn Bryan) Hobart 1990 pp 18-20

Have you got a death wish?
If so, become a navigator

Most of the early navigators who touched our shores died early in their careers for various reasons, including: shipwrecks, disappearances, attacks by natives or from poor hygiene and diet aboard ships. The exceptions were Tasman, Bligh and Hayes who lived somewhat longer. Some examples are:

* **Marion du Fresne aged 48** anchored briefly at Marion Bay near Dunalley in 1772. After leaving Van Diemen's Land for New Zealand, du Fresne and many of his crewmen were killed, mutilated and eaten by Maoris. Second in command Capt. Julien Crozet, reportedly killed 250 Maori villagers in revenge. This appears to be logistically impossible given the unreliable weapons of the day.
* **Tobias Furneaux** (1735 -1781) charted our east coast in 1773 and sailed to Queen Charlotte Sound, New Zealand where nine of his crew were killed and eaten by the Maoris. Furneaux escaped the carnage and returned to England in 1774. He died **aged 46** at his birthplace in Swilly, Plymouth, Devon on 19 September 1781.

- **Capt. James Cook** (1728 – 1779), on his third voyage to the Pacific on the *Resolution* and Charles Clerke in command of the *Discovery*, anchored in Adventure Bay on the 26th January 1777. Cook sailed for New Zealand, and explored north discovering the Sandwich Islands (Hawaii) in February 1778. At the **age of 51 years** Cook was killed at Kealakekua Bay, Hawaii on the 14 February 1779 when he was struck heavily on the head by native warriors before they passed around a knife to mutilate his body. In the sudden attack four of Cook's marines were also killed.
- **Rear Admiral Bruny d'Entrecasteaux** (1739 – 1793) explored and charted south-eastern Van Diemen's Land in 1792/3 during his expedition to search for the missing Count La Perouse. After he sailed off in March 1793, d'Entrecasteaux died of dysentery and scurvy at the age of **54 years** on 21 July 1793. His deputy and almost 40% of the French crew suffered the same fate at this time.
- **Surgeon George Bass** (1771 - c1803) is best known for proving (with Flinders) the existence of Bass Strait in 1798. George Bass sailed from Sydney into the Pacific in 1803 aboard *Venus* a commercial cargo ship, with a cargo to sell in South America. The ship disappeared and Bass at the age of 32 years was never seen again. Reports that he was captured by the Spanish and forced to work as a slave in the silver mines of Peru were never verified.
- **Matthew Flinders,** (1774 – 1814) In 1798 (with George Bass) sailing south from Sydney Town in the *Norfolk*, sailed through Bass Strait in 1798 and circumnavigated Van Diemen's Land, proving it to be an island. On his way to England Flinders called in at Mauritius for repairs but was captured and imprisoned by the French, claiming he was a spy. Flinders was imprisoned in Mauritius until 1810. Returning to London, he was in very poor health but still managed to complete a book on his explorations and named it *"A Voyage to Terra Australis".* Matthew Flinders died **aged 40 years** on the day his book was published.
- **Nicolas Baudin** (1754 – 1803) In November 1801, Baudin sailed for Van Diemen's Land with most of his crew becoming ill; he sailed directly for D'Entrecasteaux Channel entering it on January 13th 1802. Baudin died of tuberculosis in Mauritius 16 September 1803, **aged 49 years**.[75]

The moral of this article is: if you aspire to become a navigator, don't expect to celebrate your 60th birthday or draw the age pension.

75 *ADB*

The Epic Saga of the *Phatisalam*

The ill-fated voyage of the 259 ton fully rigged ship *Phatisalam* (Capt. Peter Dillon) was dogged with difficulties, fatalities and disasters from the start (it didn't finish). The story began in Calcutta on 25 January 1821 when the five years old ship grounded in the Hoogly River as she left for Sydney with a valuable cargo of 6,000 gallons of rum. When she got off, she grounded again at Madras where she had to put in for some urgent repairs to stop persistent leaking. In hindsight, she should never have left Madras as she was unseaworthy and she continued to leak badly during her voyage which was destined to take nine and a half months. The pumps had to be manned continually and several of the Lascar seamen perished from exposure and exhaustion.

Because of the slow voyage, her water supplies dwindled rapidly and she was on half rations when she arrived at King George Sound, Albany WA. Here she undertook some urgent, and as it turned out, futile repairs. After a stay of four weeks, the ship sailed for Sydney but leaks were still not fully repaired.

She continued to take in water at the rate of twenty inches a day as she sailed. The captain decided to head for Van Diemen's Land to try to ease the leaking and she anchored in the lee of Hunter Island on the NW tip of the island. However, luck was against him and a heavy gale sprang up the anchors parted and she was driven ashore in Coulomb Bay, Three Hummock Island. All hands safely reached shore, but it became clear that help was required and the ship's longboat was despatched to Port Dalrymple the next morning. However, disaster struck again and the boat was upset and eight crewmen were drowned. The captain recovered the boat and he and seven others set off to seek assistance arriving at George Town twelve days later. Capt. Dillon chartered the brig *Glory* to pick up the remaining survivors and salvage the cargo. The schooner *Little Mary* was also sent to assist. Dillon found the vessel to be a total wreck when he arrived, but he succeeded in salvaging some of the cargo.

The *Glory* arrived in Sydney on 4 November 1821 with salvage, Dillon, his wife and child and eleven surviving Lascars. Capt. Dillon rose to fame when in 1827 he found relics of two well-equipped French ships *Boussole* and *Astralobe* at Vanikoro Island in the Santa Cruz Group. The ships had been commanded by the missing French explorer Comte de La Perouse. The expedition disappeared after leaving Botany Bay on 10 March 1788 and several new expeditions were mounted by the French government from 1791 onwards in an endeavour to find the missing navigator and his crew. As a reward for solving the thirty nine years old mystery, Dillon was invested with the French Chevalier of the Legion of Honour and given a pension of 4,000 francs per annum.[76]

76 *Sydney Gazette* 28 October 1820; *Wrecks in Tasmanian Waters* op. cit. pp 12, 13

Tassie's Robinson Crusoe

One of Tasmania's best kept secrets is the story of Oscar Larsen, our very own Robinson Crusoe. The Norwegian ship *Brier Holme* (Capt. Rich) was wrecked at midnight on 5 November 1904 near Giblin River, thirteen miles north of Port Davey. The sole survivor of the wreck was a Norwegian sailor Oscar Larsen aged twenty nine years of age. He survived for three and a half months on tinned food washed up on the beach from the wreck. Amazingly Larsen had been wandering up and down the Port Davey Track looking for civilisation from 6 November 1904 until 13 February 1905, returning to the wreck each time he ran out of supplies.[77] The story of the wreck is summarised in the following article:

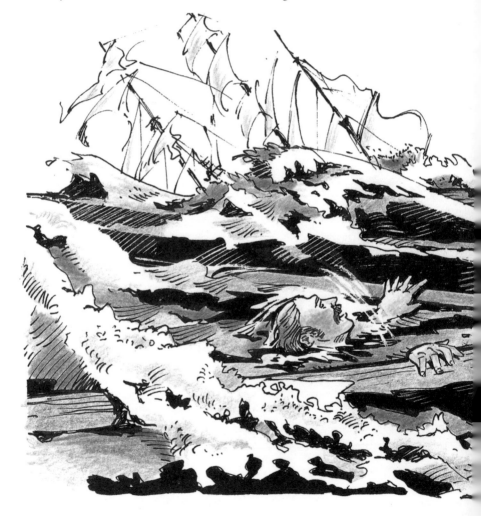

77 Further reading: *Pioneer Shipping* (L. Norman) Shearwater Press Sandy Bay 1989 p 177

'The *Brier Holme* was a beautiful iron barque of 921 tons built in Sunderland in 1876. She met her tragic fate in 1904 when sailing under the house flag of Hine Bros of Mary Port. ... The *Brier Holme* sailed from London for Hobart on 21ˢᵗ July under Capt. JH Rich who had made many Tasmanian voyages. Mrs. Rich usually accompanied her husband but, as this was to be his last voyage, she remained behind to prepare a home for his retirement. Sadly it was his last voyage. The *Brier Holme* was a staunch and well-found vessel with a crew of eighteen. When she failed to arrive by the end of October, no great anxiety was felt as it was thought that she might have been delayed by the loss of some spars during stormy weather. By the end of November she was 133 days out. At that time many French bounty ships were calling at Hobart for orders but none of them had sighted her or seen any wreckage. Reluctantly she was given up and posted at Lloyd's as 'Missing'.

Then on 3 January 1905, came startling news. Harry Glover of the fishing smack *Lenna* had discovered on the beach, between Port Davey and the South West Cape, much wreckage.'[78]

The SS *Seabird* (Capt. James Davis) was sent to investigate the find with a group of searchers to look for survivors. They found a camp but no sign of a fire. As they found no trace of survivors the ship returned to Hobart. There was uproar in Hobart at the 'premature abandonment' of the search and another party was sent in the SS *Breone* under Mr. CH Crisp, an experienced surveyor; but it too found no survivors. Finally, the sole survivor of the wreck was discovered on 13 February 1905 by fishermen Edward 'Ted' Noy and Tom Pretty. Larsen was taken aboard the fishing smack *Britannia* (Ted Noy) where he was given a good hearty meal. When he was found, Larsen was suffering from scurvy and only had enough food salvaged from the ship to last another four days, so the rescue mission was indeed timely. He explained how the ship was wrecked off the south west coast on the evening of the 5ᵗʰ November in thick fog and amid heavy rain and wind. The smack went to the site of the wreck and salvaged as much as possible before sailing to Hobart to break the news.[79]

78 Further reading: *Wrecks in Tasmanian Waters* op. cit. p 127
79 Ibid pp 128-133

The upside-down world of Lt. Robbins

An amusing incident occurred in 1802 after Governor King of NSW had heard rumours *'that the French intended to settle in Storm Bay Passage* [D'Entrecasteaux Channel], *somewhere about what is now called Frederick Henry Bay'*. King penned a letter of protest to French Commodore Nicholas Baudin requesting an explanation. King gave this letter to Lieutenant Charles Robbins who was sent aboard the schooner *Cumberland* to locate Baudin who was conducting scientific experiments in Bass Strait. The *Cumberland* left Sydney in such a hurry that it sailed without some necessary supplies. Robbins finally located the French fleet at King Island and he anchored his little ship alongside the much larger French ships *Geographe* and *Naturaliste*. Robbins had vague instructions *'to make the French Commodore acquainted with my intention of settling Van Diemen's Land'*. Robbins wasted no time in delivering Governor King's letter to Baudin and acquainting him with his instructions.

A week later Robbins decided that it was time to ceremonially claim King Island, Bass Strait and Van Diemen's Land for the British Crown. He and his party, in full view of the amused Frenchmen hoisted the British flag in a large gum tree on the island. Then he posted a guard of three marines who fired three volleys in salute low over the nearby French tents, accompanied by three loud cheers. This was a rather stupid and provocative gesture as the one hundred plus Frenchmen well and truly outnumbered the seventeen British sailors, and matters could have become serious if the French had taken umbrage at the immature gesture. Baudin wrote the following sarcastic letter on 23 December 1802 to King:

'I gave Mr. Robbins, without regard to his having placed his flag over our tents, everything he required from me in the shape of gunpowder, sails, thread, needles, lead and sounding line, old ropes etc. Our forge worked two days for him. I was unable to replace the anchor which he had lost, having none to suit him.'

To make Robbins's provocative actions even more bizarre, the salutes were fired using gunpowder borrowed from the French, and the British flag was hung upside down. Baudin also sent a private letter to Governor King which included the following caustic extract:

'That childish ceremony was ridiculous, and has become more so from the manner in which the flag was placed, the head being downwards and the attitude not very majestic. I thought at first it might have been a flag which had served to strain water and then been hung out to dry.' ...

Baudin then went on to make some incisive and prophetic statements:

> 'I am sorry that King's Island bears your name inasmuch as it appears to me to be of no use whatever except as a resort for sealers. … in a short time your fishermen will have drained the island of its resources by the fishing of the sea-wolf [seal] and the sea-elephant … and if you do not issue an order you will soon hear that they have entirely disappeared. …

A tale of woe

Some sailors seem to be dogged by misfortune wherever they go and Capt. John Howard was such man. In 1819 he was caught up in a chain of unfortunate disasters leading to the loss of three of his privately owned ships, two treasure chests and eventually, his own life.

John Howard sailed his well-stocked ship *Duke of Wellington* to Van Diemen's Land in 1817. He quickly set up as a merchant at Macquarie Point in Hobart Town and sold large quantities of goods that he had brought with him. However, he failed to find a local market for some gold, silver and jewellery that he kept for safety in a heavy half-ton safe together with some bullion and English banknotes. The total contents of the safe were estimated to have been worth £2,000 and he lost the lot when his house was burgled in January 1819. The safe was found later but the robbers and Howard's small fortune were never seen again.[80]

Howard purchased the *Henrietta Package* and renamed it the *Young Lachlan* in honour of the son of NSW Governor Lachlan Macquarie. However, the ship was seized in Hobart on 28 February 1819 by thirteen escaped convicts.

The pirates sailed off to Java in her where they sank the ship to avoid detection. Nevertheless, the escapees were captured, but their fate is uncertain.[81]

80 Further reading: *Lawless Harvests* op. cit. pp 79-80

Howard then sent a cargo of sheep and cattle on his ship the *Duke of Wellington* to Mauritius but all died of heat trauma off Percy Island (Northumberland Group). The ship then sailed to Batavia where the captain died and the crew deserted. The fate of the vessel and its remaining cargo is unknown.[82]

Undaunted, Howard sold some of his assets and purchased the brig *Daphne* at Sydney which arrived in Hobart Town on 1 July 1819. Howard then reinvented himself as a trader in seal skins to regain his lost fortune. The *Daphne* sailed from Sydney via Bass Strait for India on 10 October 1819 and encountered heavy weather. Howard sheltered on the 26th in the Kent Group of islands, sited north west of Flinders Island in Bass Strait. Unfortunately, the brig drifted on to the rocks and broke up within ten minutes. Howard managed to salvage a bag containing £400 and some provisions and left them on the island with some castaway crew members on 4 November. Howard then sailed off in the longboat to seek help at George Town. Contrary winds forced him to sail to Hobart Town where the small crew arrived safely on the 14 November.

In the meantime the sealing brig *John Palmer* (Capt. D Smith) had rescued the *Daphne* castaways on 23 November and salvaged the £400. However, the run of bad luck continued and the *John Palmer* itself became wrecked near to the *Daphne*. Fortunately, all hands safely reached the shore but the castaways were again stranded with their would-be rescuers. However, Howard's £400 was lost.[83] After getting tired of living off mutton-birds for a few days, the castaways abandoned hope of being rescued and used a longboat to sail to Hobart Town where they all arrived safely. In the meantime, Capt. Howard had left Hobart Town in the chartered sloop *Governor Sorell* to rescue the *Daphne* castaways he had left at the wreck site. Neither Howard nor the sloop *Governor Sorell* were ever heard of again, but wreckage from the ship was later found floating in Bass Strait near Cape Barren Island. And you thought that YOU were unlucky.[84]

The disastrous wreck of the *Cataraqui*

The 802 ton Canadian-built barque *Cataraqui* (pronounced ka-tah-RAH-kway) piled up on the rocks off King Island on 4 August 1845. Four hundred people perished, making it the worst recorded Tasmanian shipwreck (and Australia's third worst) based on the loss of life.

The ship had sailed from Liverpool, England under Capt. Christopher Finlay with 367 assisted emigrants and 41 crew members.

81 *Shipping Arrivals and Departures Tasmania Vol 1* op. cit. pp 53, 59;

82 Ibid. p 50

83 Ibid. p 56

84 Further reading: *Pioneer Shipping* op. cit. p23; *Shipping Arrivals and Departures* op. cit. pp 48, 53, 55, 56, 57; *Wrecks in Tasmanian Waters* op. cit. pp 11-12

On the evening of the wreck, the captain thought that he was 60-70 miles northwest of King Island so it was quite a shock when the ship in a howling gale struck some jagged rocks off the south-west coast of King Island.

The holds quickly filled with water and the crew managed to get most of the passengers on deck despite the fact that the ladders below decks were swept away. Huge seas rolled over the decks washing many people overboard to be dashed to pieces against the rocks. Two hours later the ship rolled and more people fell from the decks to their doom.

Just before daybreak there were only half of the ship's complement of 409 left and some of these clambered into the one remaining life boat. When it was launched the boat was swamped drowning the five or six occupants. To add to the confusion the hull parted and the stern collapsed and 70-100 people were swept away.

The ship soon disintegrated and the remaining survivors on deck were thrown into the water.

At daybreak only 30 survivors remained. It was decided that it was too dangerous to swim ashore so the survivors were urged to cling to some wreckage and try to drift ashore. This was a perilous task in the raging waters and only one emigrant and eight crew members managed to reach the shore.

The survivors were lucky to have been spotted the following day by the Strait's policeman David Howie who had been alerted to the disaster when he saw wreckage strewn along the coast. It was pure luck that Howie was on the island, as he had been trapped there, when his own boat had been wrecked earlier. The small party of survivors were forced to remain on the island for five weeks before they were rescued by the cutter *Midge* on 7 September.

While they had been awaiting rescue, the castaways had managed to complete the gruesome task of burying the 342 bodies that had washed ashore. The bodies were interred in four mass graves, one of which contained around 200 bodies. News of the wreck quickly spread in Melbourne and several public events were held in all of the Australian colonies to raise funds for the survivors who had lost all their possessions in the wreck. An iron memorial was later erected close to the site of the wreck in 1846 and after it had rusted away, it was replaced by a concrete memorial in 1956.

NB. The ship was built at Quebec in 1840 and was named after a suburb of Kingston, Ontario, Canada which in turn is sited near the Cataraqui River and Cataraqui Creek. Cataraqui is an Iroquois Indian word meaning 'where the rivers and lake meet' referring to the St Lawrence and Cataraqui Rivers joining with Lake Ontario.[85]

85 Further reading: *Tasmanian Shipwrecks* (Broxam & Nash) p 56;
http://www.carf.info/kingstonpast/frenchcataraqui.php#settle;
http://www.navy.forces.gc.ca/navres/units/navres_units-ships_e.asp?category=96&title=806

Hebe geebees

Hebe Reef at the entrance to the Tamar River is arguably the most dangerous reef in Tasmania's waters. The reef is named after the fully rigged sailing ship *Hebe* 250 tons, the first of many ships to come to grief here. *Hebe* set sail from Madras, India with a large and varied cargo of Indian produce and one passenger. The master Joseph Leigh decided to put into Port Dalrymple on 15 June 1808 but instead, left her bones on the reef that was eventually named after her. In the confusion following the striking of the reef, one Lascar sailor was washed overboard and drowned. The remaining crewmen were saved and were transported on 11 October 1808 to Sydney aboard the *Estramina*. In due course, most of the cargo was salvaged. There are at least eleven ships known to have struck this reef and these are: *Hebe* 1808, *Phillip Oakden* 1851, *Atlanta* 1858, *Mariner* 1861, *Olive* 1879, *Asterope* 1883, *Windward* 1890, *Eden Holme* 1907, *Bonita* 1915, *James Wallace* 1971, and *Iron Baron* 1995.[86]

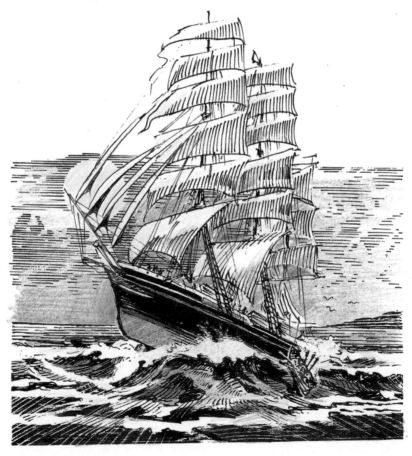

86 Further reading: *Tasmanian Shipwrecks* op. cit. p 4

Epilogue

Just as the notorious Hebe Reef was the graveyard of many ships over the years, the article about the reef has led to the end of this first volume of *Ripper Tassie Tales*. I hope that you have enjoyed reliving some of the most humorous, adventurous, exciting, bloodthirsty, gruesome and unbelievable moments of Tassie's unique history. Likewise, I sincerely hope that you appreciated the amusing tall tales and anecdotes in this book, some of which may be masquerading as truth. There are hundreds of similar gripping tales just waiting to be told (and retold) for the benefit of our future generations. If this book is the success envisaged, more volumes featuring further ripper Tassie tales can quickly be assembled and published to ensure that we can keep alive some of the wondrous stories of our past.

Index

M

Macquarie, Governor 13,26,27,46,75,95
Mansfield, Michael 46,47
Markham, Edward 89
Masefield (pilot) 76
Mason, Capt. R 27
Mathers, John 42
Maule, Capt. William 81
Maycock, Capt. William 83
McArra, James 38
McGiveran, James 54
McGuire, Thomas 16
McHugo,
 Count Jonathon Burke 27
McKay, Donald 77
McKinnon (farmer) 77
McPartland, Constable 64
McRorie (farmer) 71
Meguro, Yoshiichi 88
Merite, Ensign 78
Merrick, Capt. 81
Miss Hobart (aeroplane) 61
Monds, Thomas 11
Morton, Dr Samuel 42
Mount Dromedary 13
Mount Nelson 13
Mount Wellington 13
Murphy, James 38
Murray, Lt. John 75
'Muzza' (shearer) 28-29

N

Nakayama, Capt. 88
Nelson, Lord H. 11,13
Nicol, John 79,80
Noy, Capt. Edward (Ted) 95
Nyllavert 57

O

O'Brien, Miss 18
O'Hara, Edward 44
Ogilvie, James 17
Old Stone House ghost 62,63

P

Page, F 18
Pagerly (Aborigine) 83
Parish, James 44
Park, Henry 76
Parker, Critchley 65
Patterson (surveyor) 71
Pearce, Alexander 1,13,42-45
Pedder, Justice John Lewes 40
Pedra Branca Island 88
Pennell, Matthew 16

Perry (bushranger) 47
Pieman River 1,13,43,44
Pitt, Sophie 13
Pretty, Tom 95
Price, Max 61
Pudding Bag Lane 18

R

Rabe, Graeme 7
Rabe, Michael 7
Ralph, George 16
Redmond, Mrs. Jean 32
Reed, Henry 22
Rex, George 23
Rice, Patrick 16
Rich, Capt. JH 95
Robbins, Lt. Charles 96
Robert (Aborigine) 83
Robey, Steve 61
Robinson, George Augustus 83,84
Robinson, Mr. 72
Running of the bulls 69

S

Sal (Aborigine) 12
Sale Street, Huonville 18
Saunders, Hamish Alan 88
Scandon, R (Bushranger) 46
Scantling (Bushranger) 46
Scott, Mr. 38
Shanck, Capt. John RN 75
Shannon Power Station 66
Ships:
 Active 27
 Anne Allen 77
 Asterope 100
 Astralobe 93
 Atlanta 100
 Aurora 81
 Bonita 100
 Boussole 93
 Breone 95
 Brier Holme 94
 Britannia 95
 Caledonia 47
 Cataraqui 98,99
 Charleston 60
 Cumberland 96
 Daphne 98
 Discovery, 92
 Dromedary 13
 Duke of Wellington 97,98
 Duke of York 47
 Eden Holme 100
 Eliza 50,51

About the author

Wayne Smith is a best-selling author, historical researcher and public speaker. He is best known for his popular Saturday morning nomenclature talk-back program with Chris Wisby on ABC Radio answering listener's questions regarding Tasmanian place names. In researching the origins and etymology of Tasmanian place names, Wayne has unearthed over a period of twenty years some wonderful stories about Tasmania's fascinating past. This has encouraged him to write this book to preserve some of the island state's priceless folklore.